Autumn Gnome

This Book Belongs To

Copyright © 2023-2024 by Al&Vy
All rights reserved

Taking care of our mental health is crucial in today's stressful environment. Because of their recent influence on us, participating in the arts has become an essential part of our self-care routine, bringing us inner peace and enjoyment.

We've watched innumerable pages come to life by imaginative colorists like you since we released our adult coloring books on Amazon. Feel free to celebrate your own creations and share photographs when you provide feedback. We are happy to view your artistic creations!

To stop bleeding, place a blank sheet under the colored page when coloring with markers.

Copyright © 2023-2024 by Al&Vy
All rights reserved

Testo Color

Copyright © 2023-2024 by Al&Vy
All rights reserved

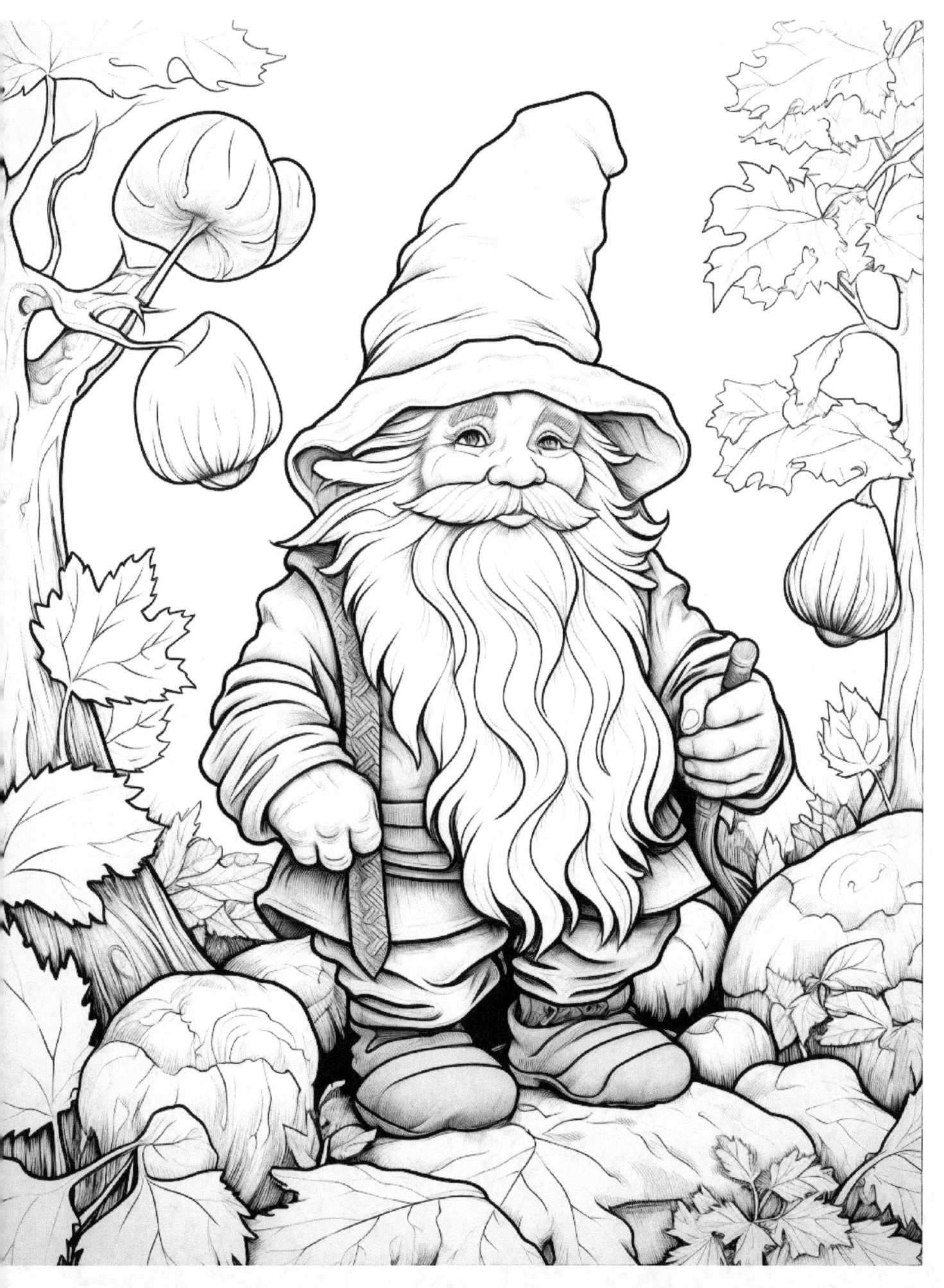

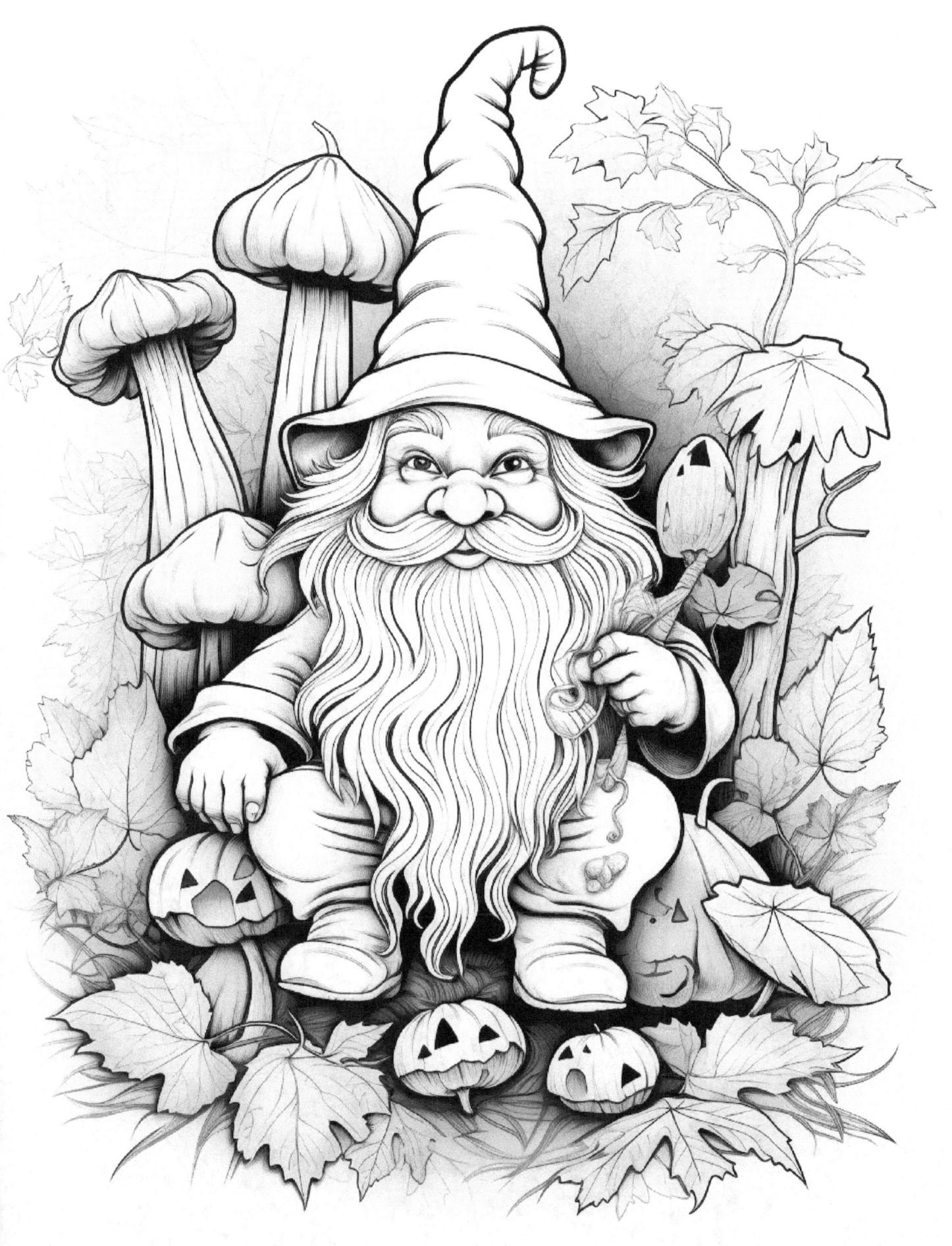

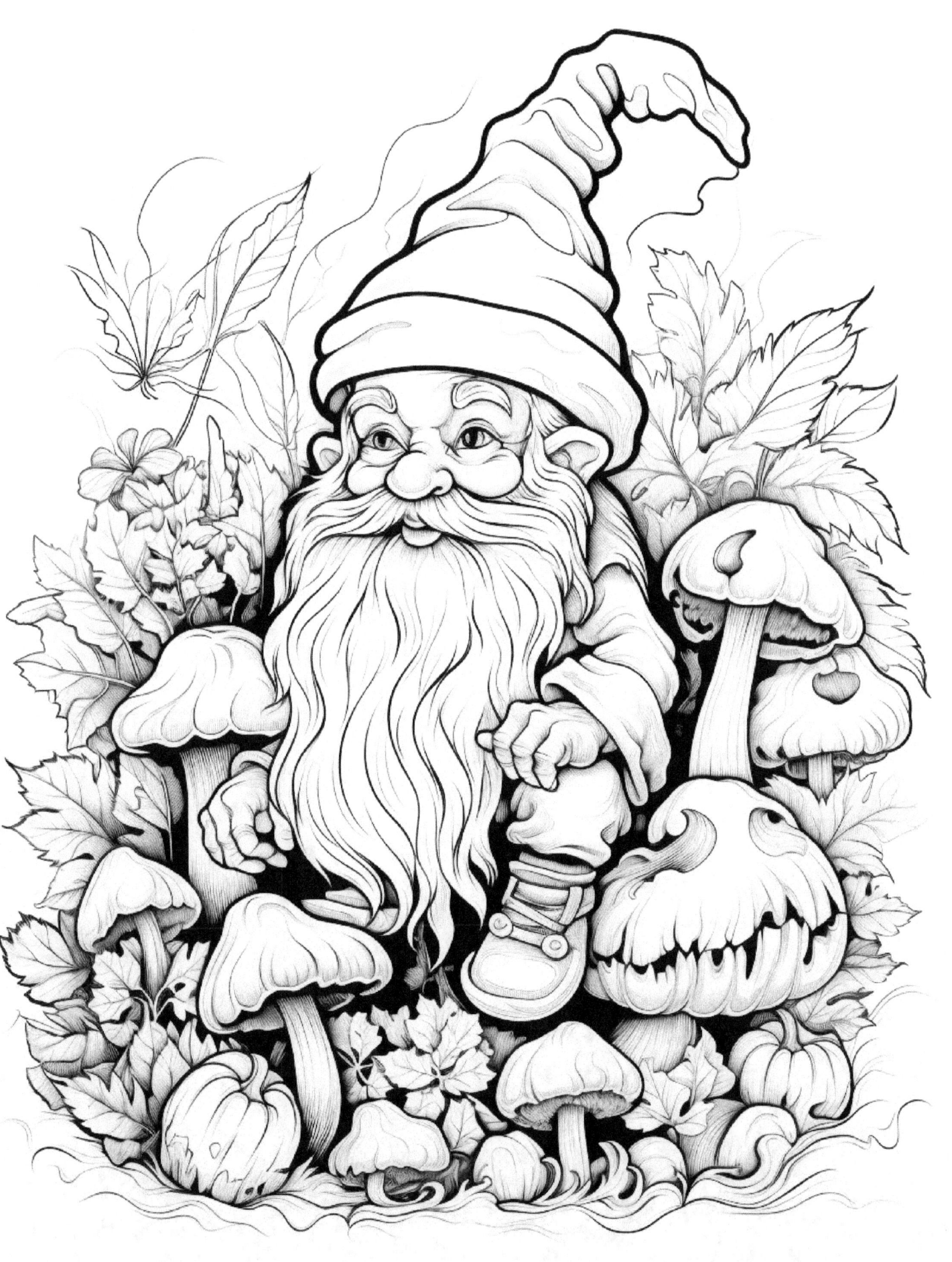

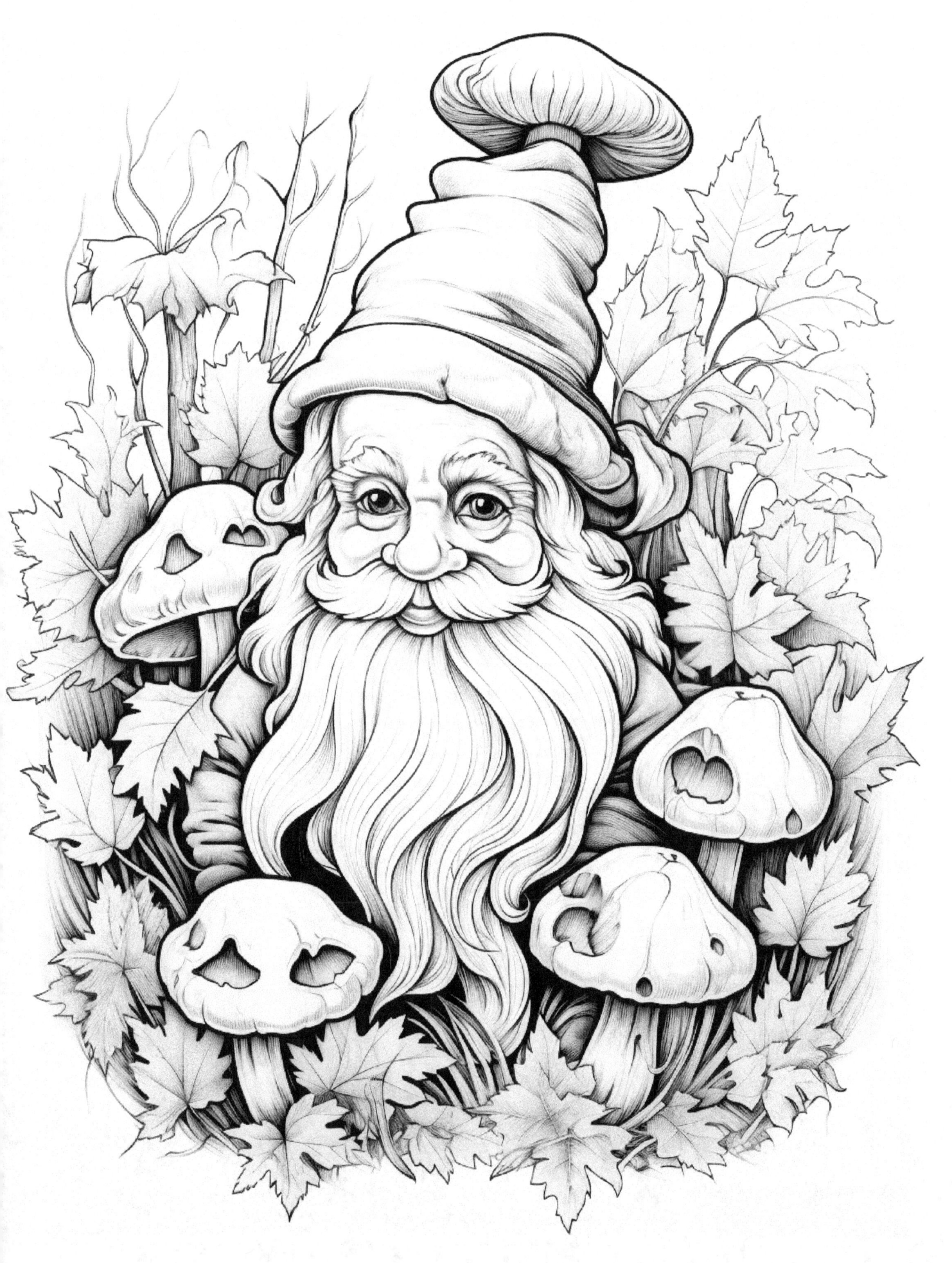

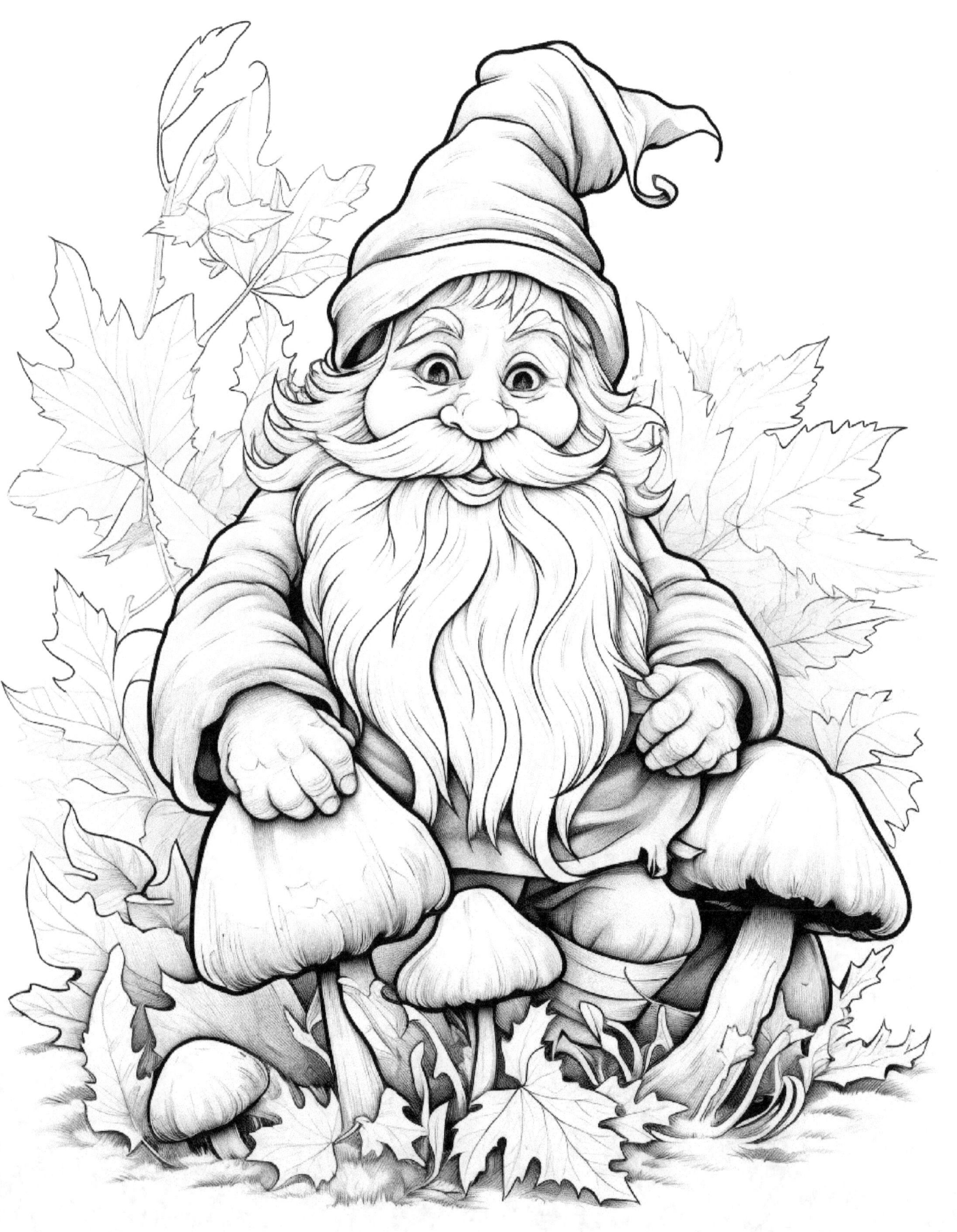

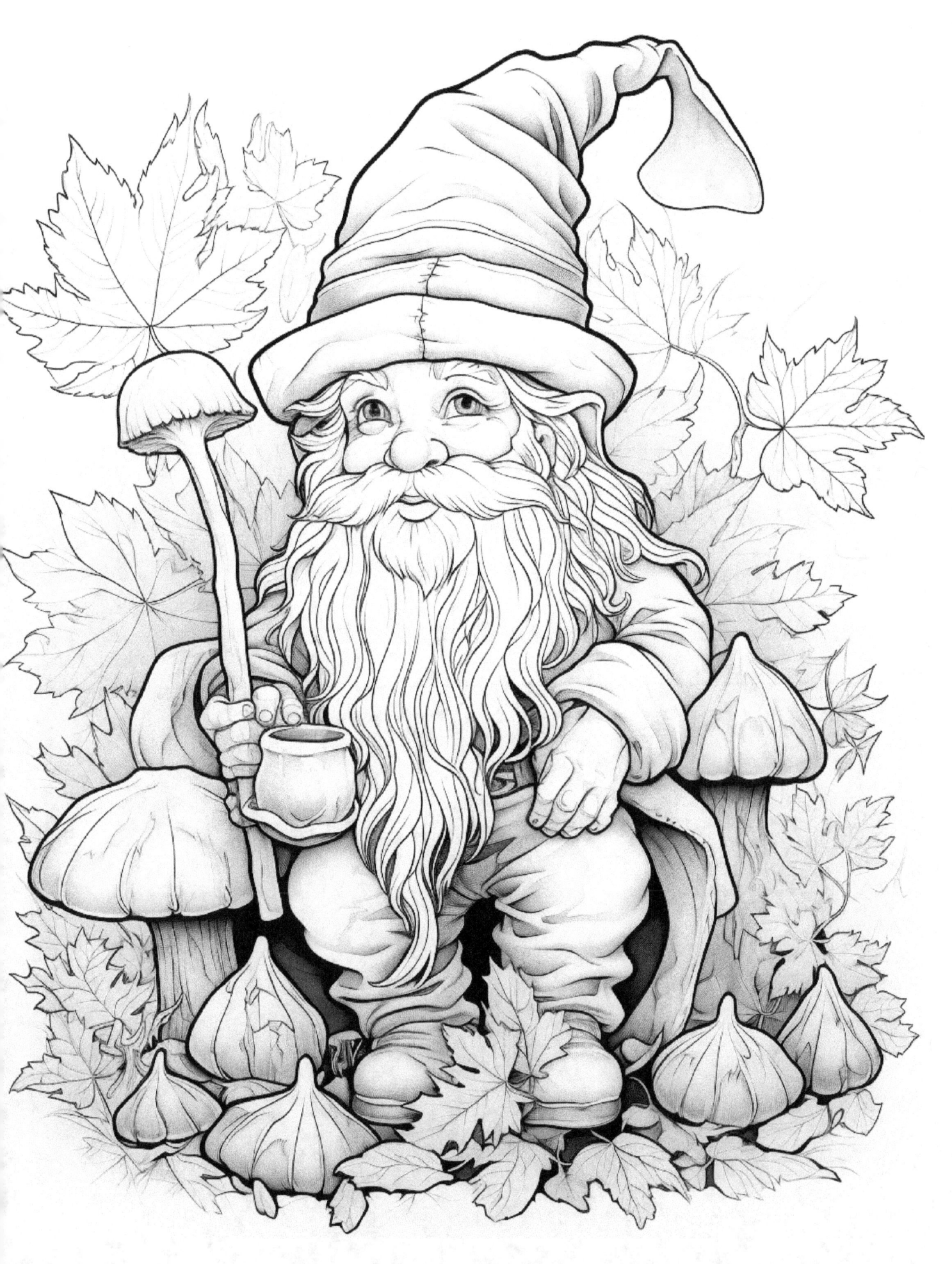

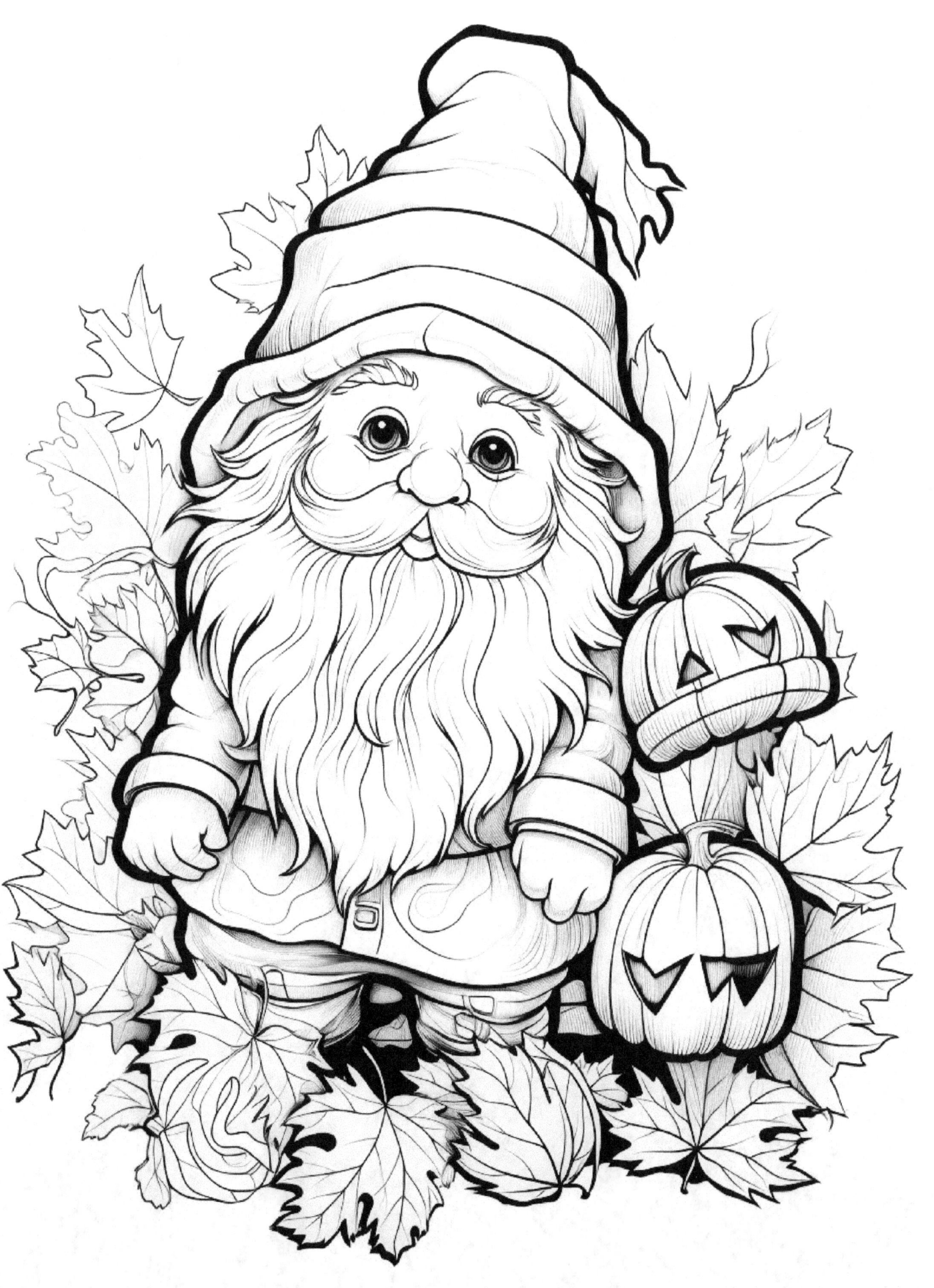

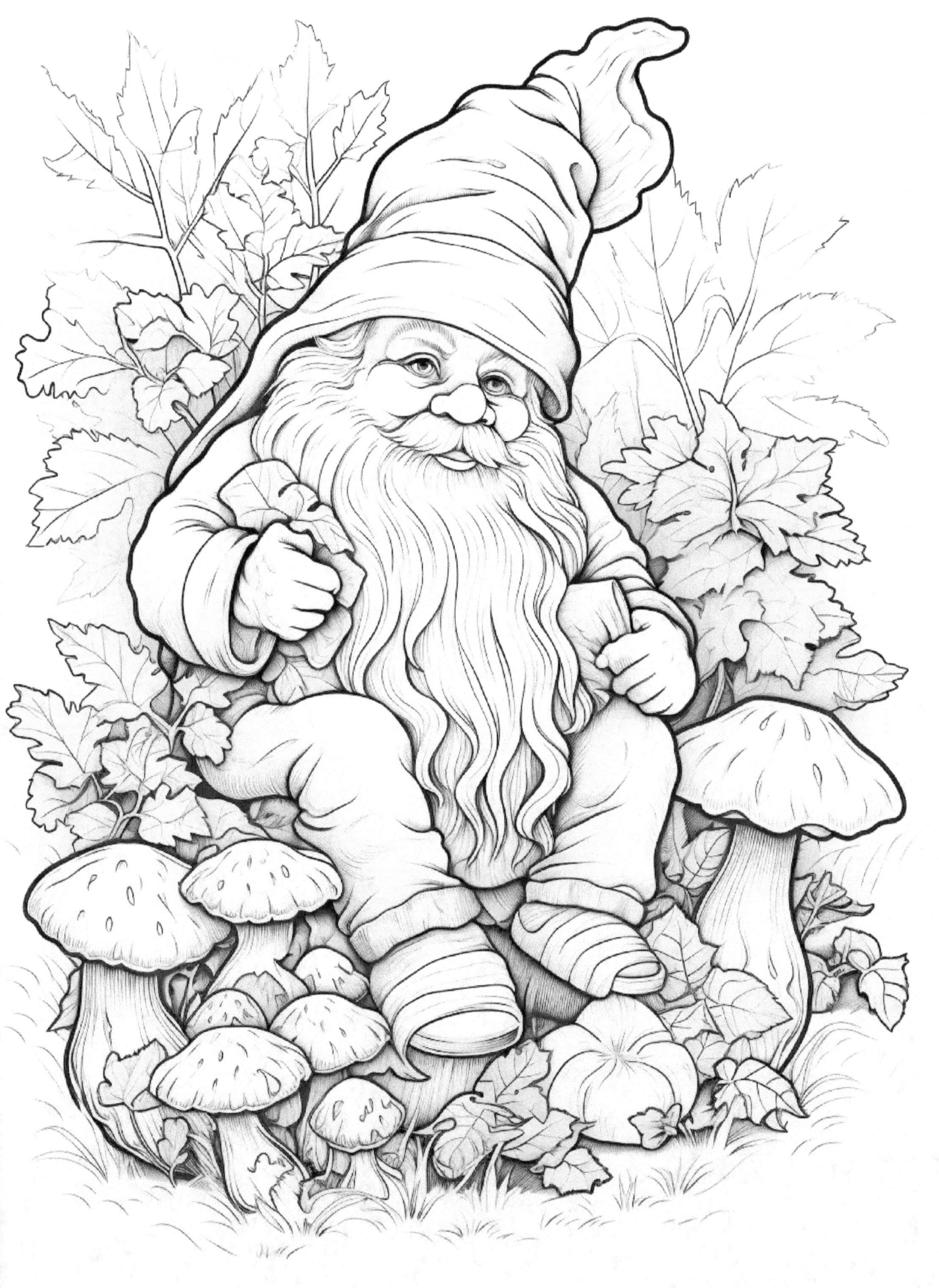

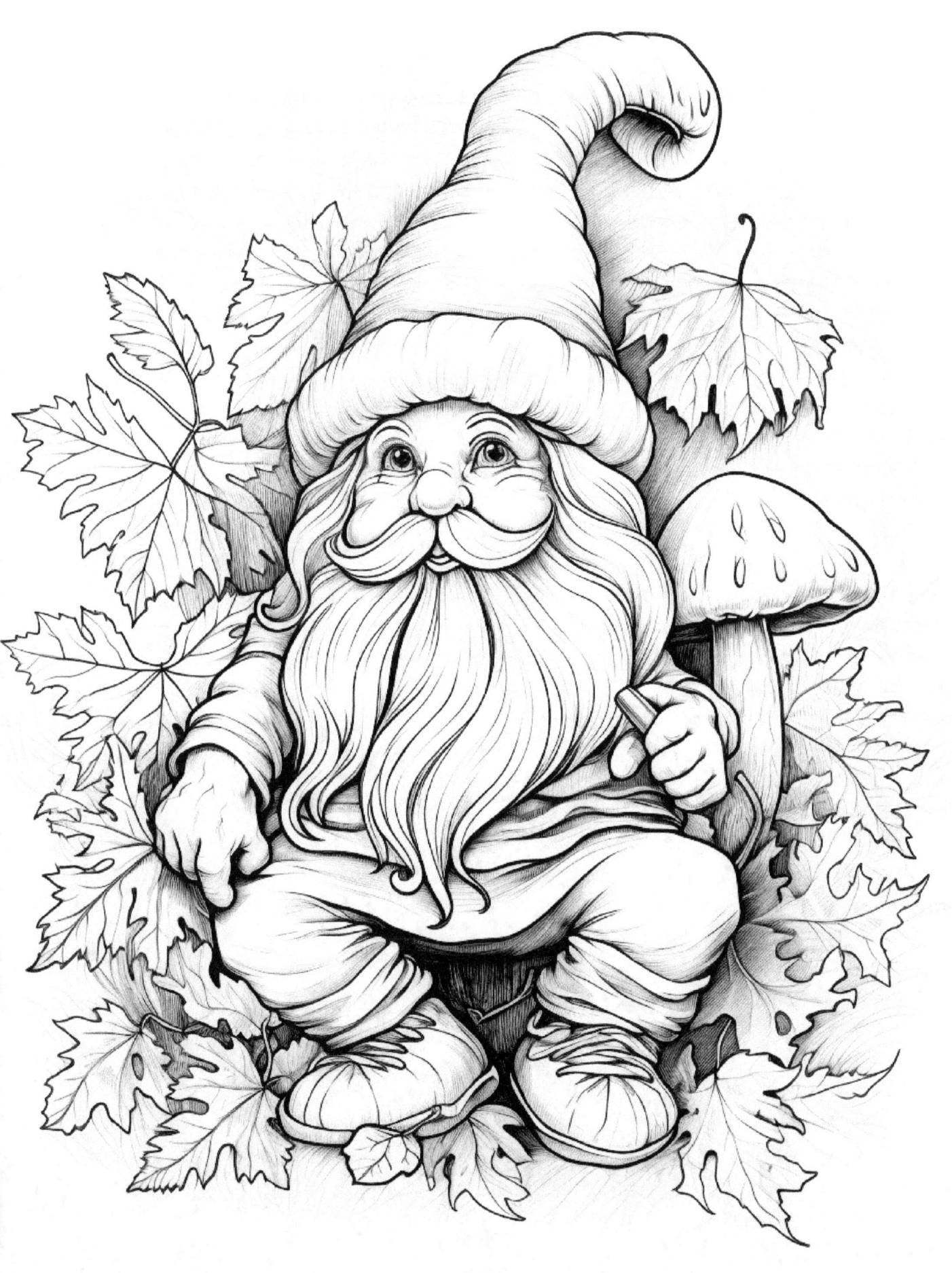

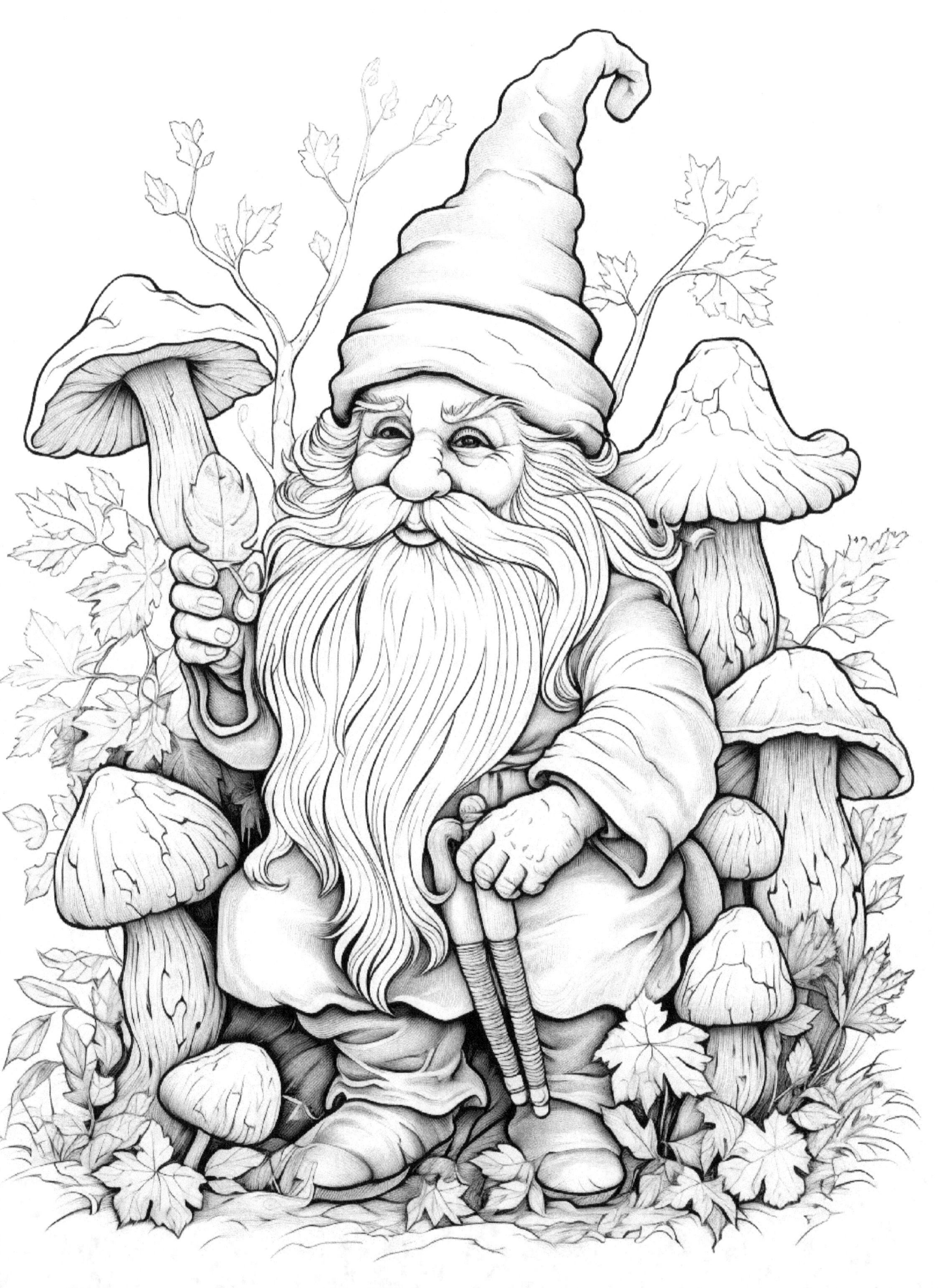

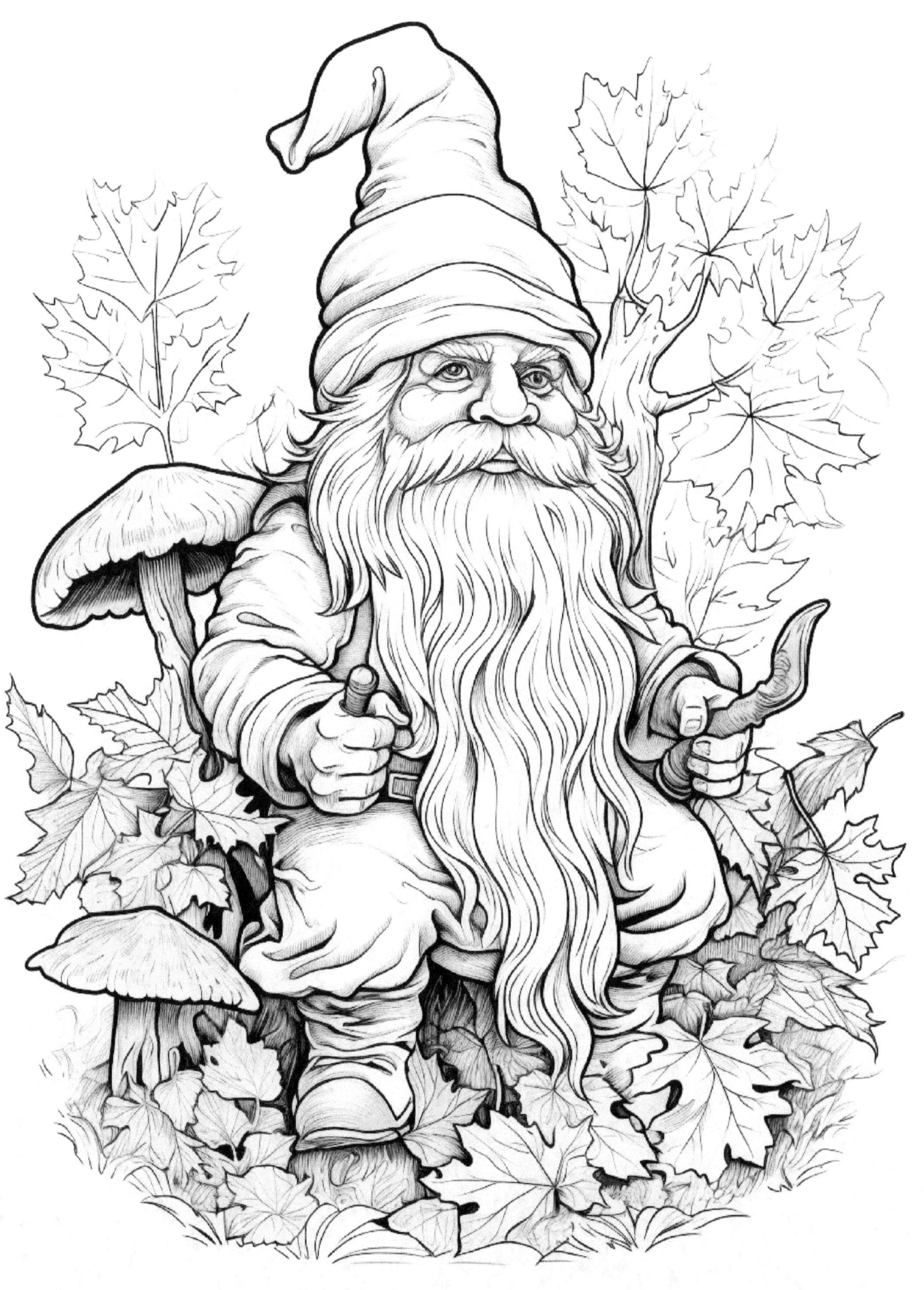

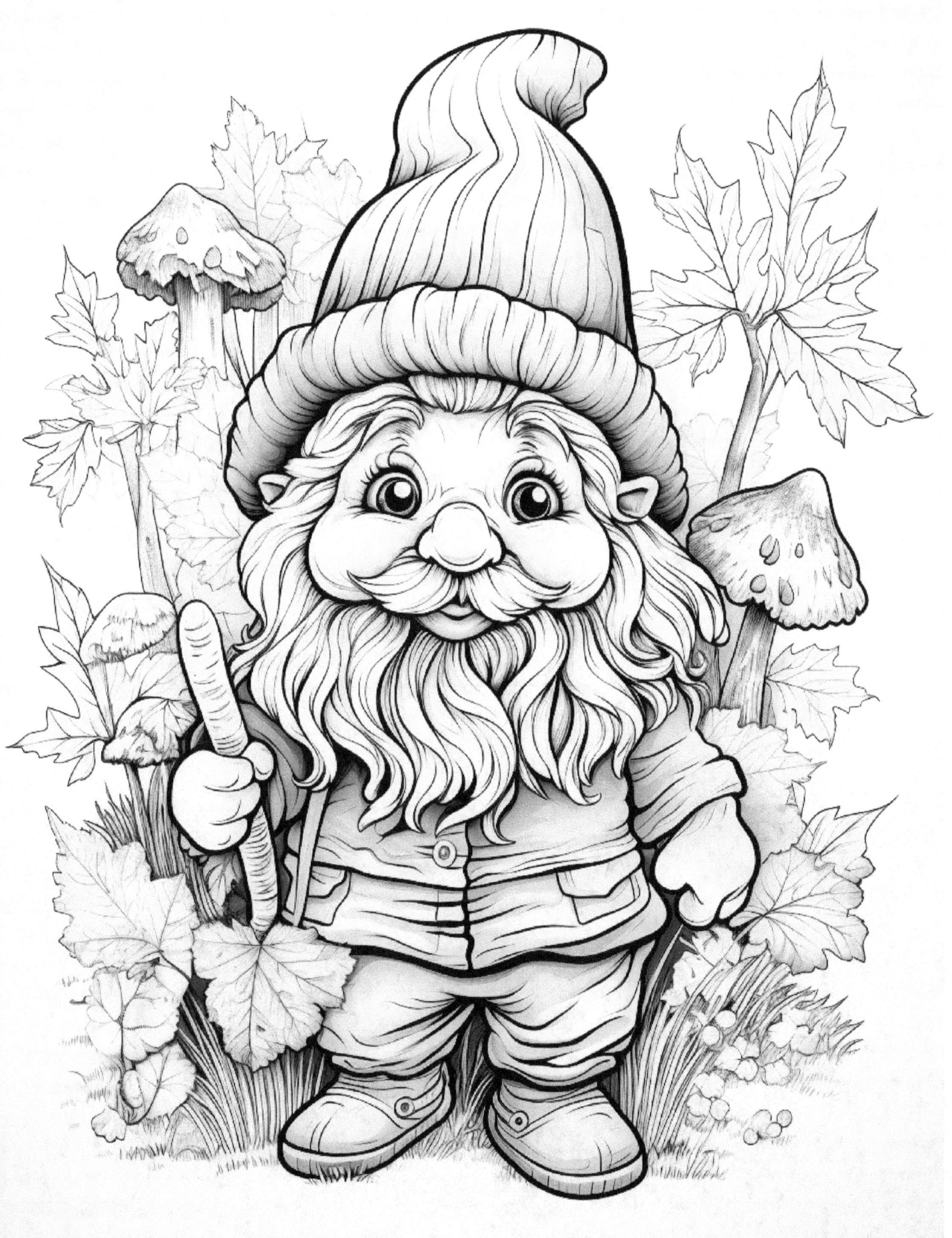

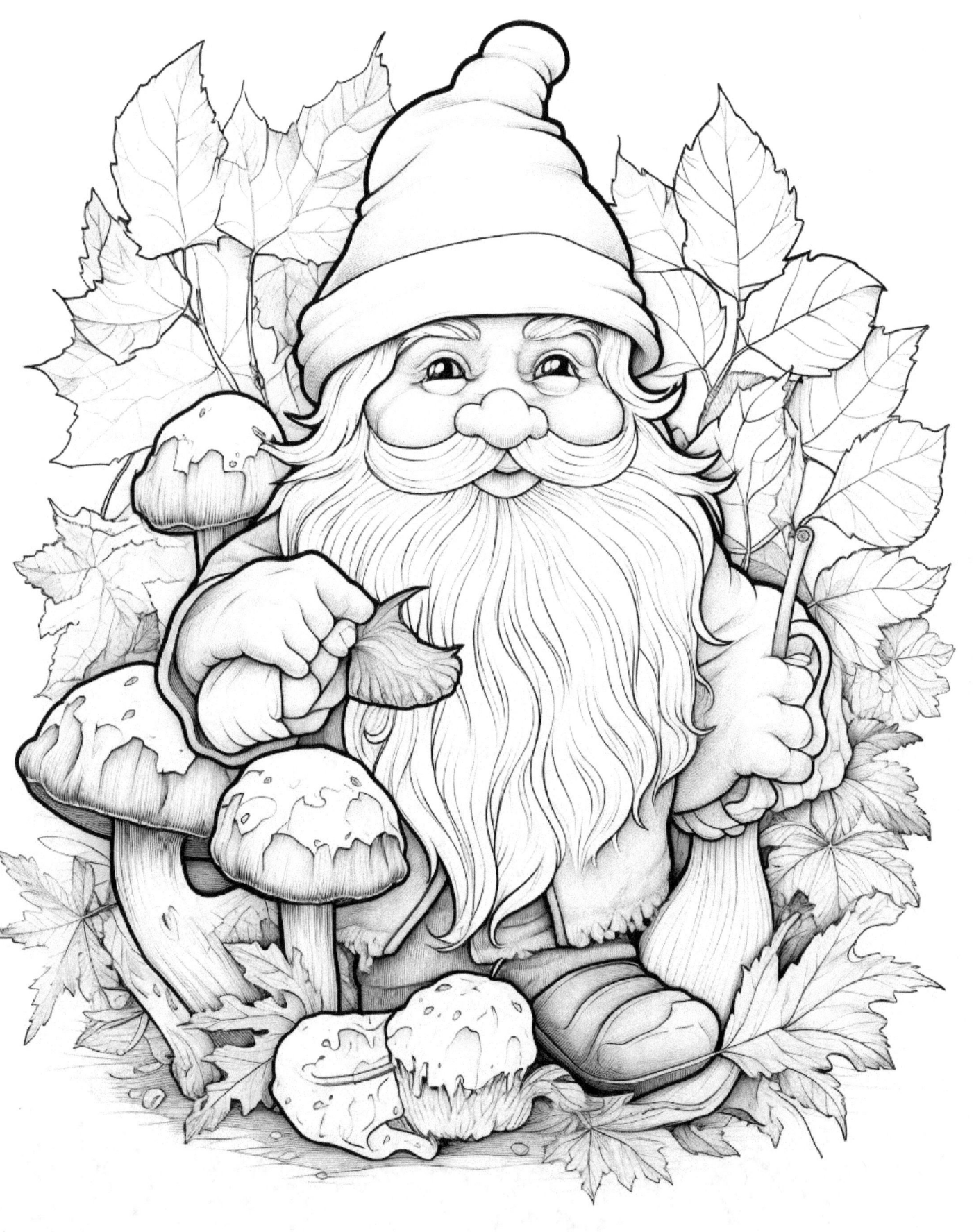

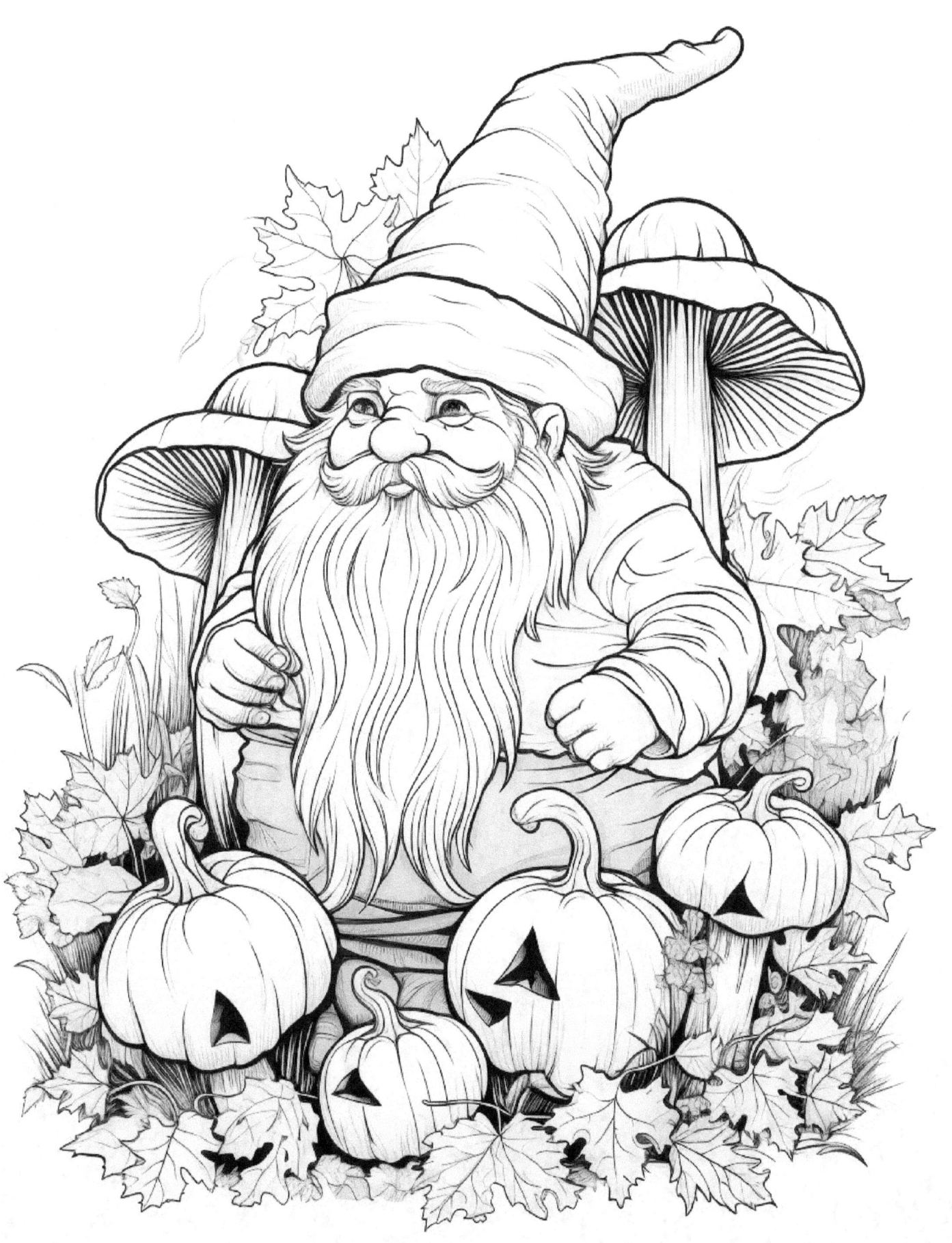

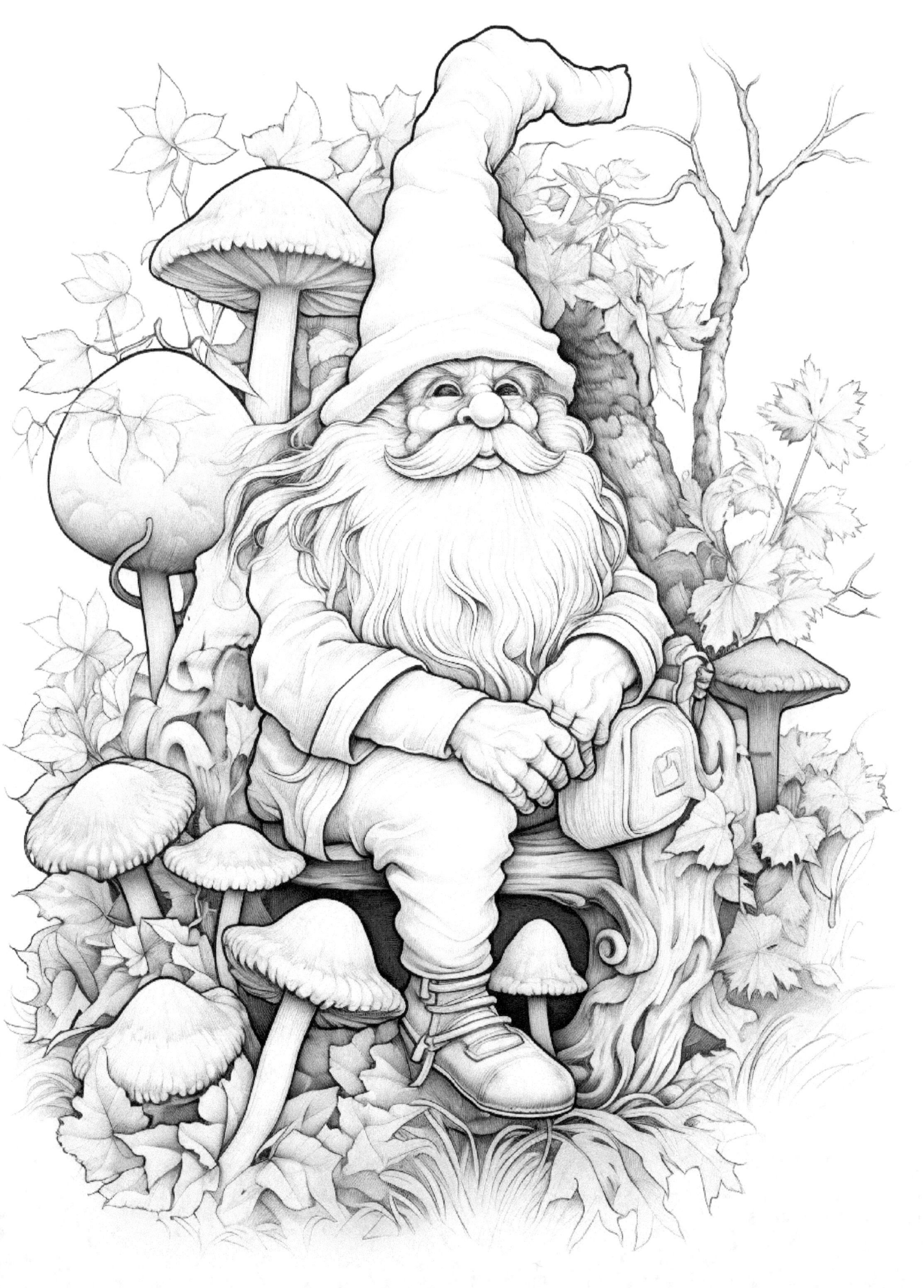

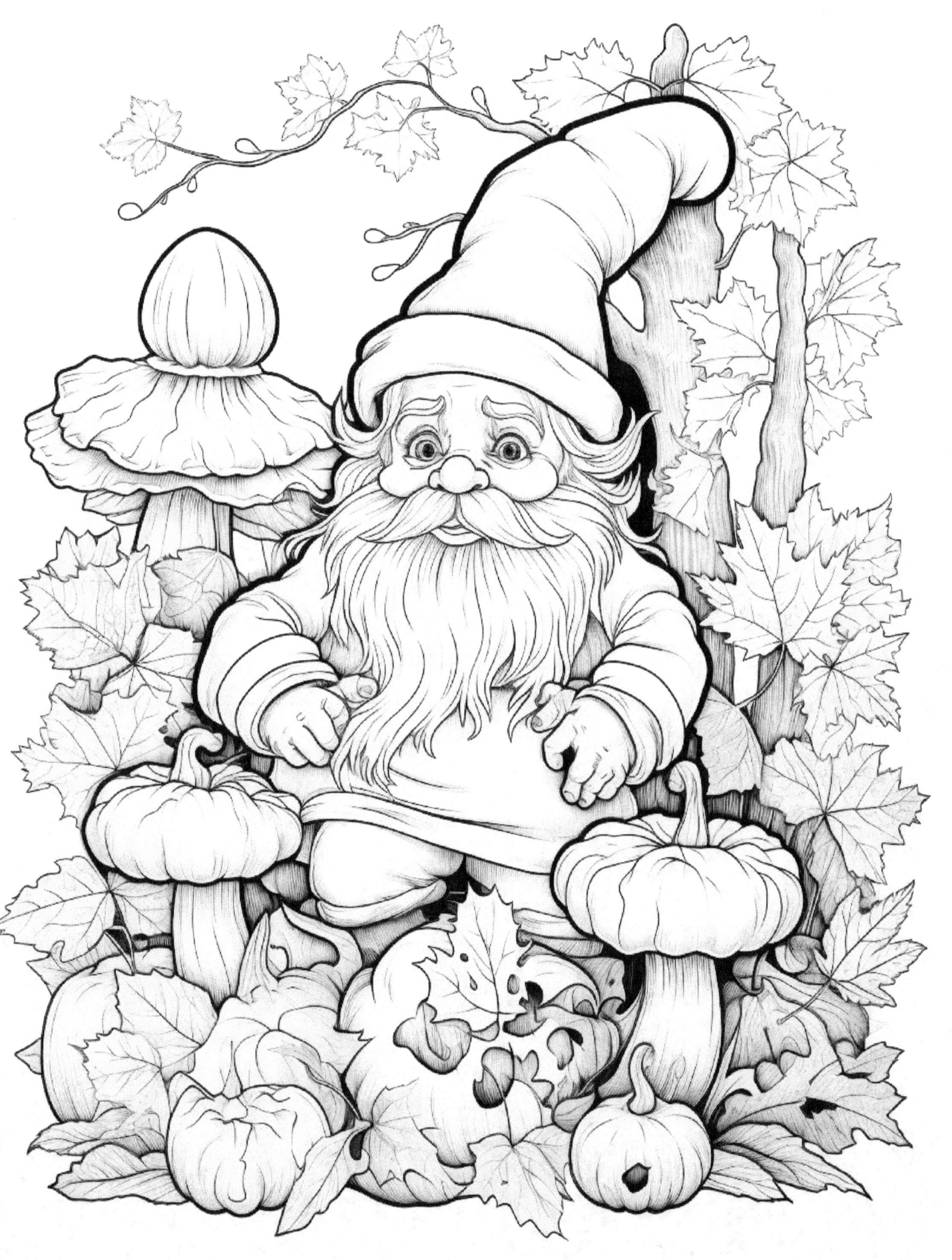

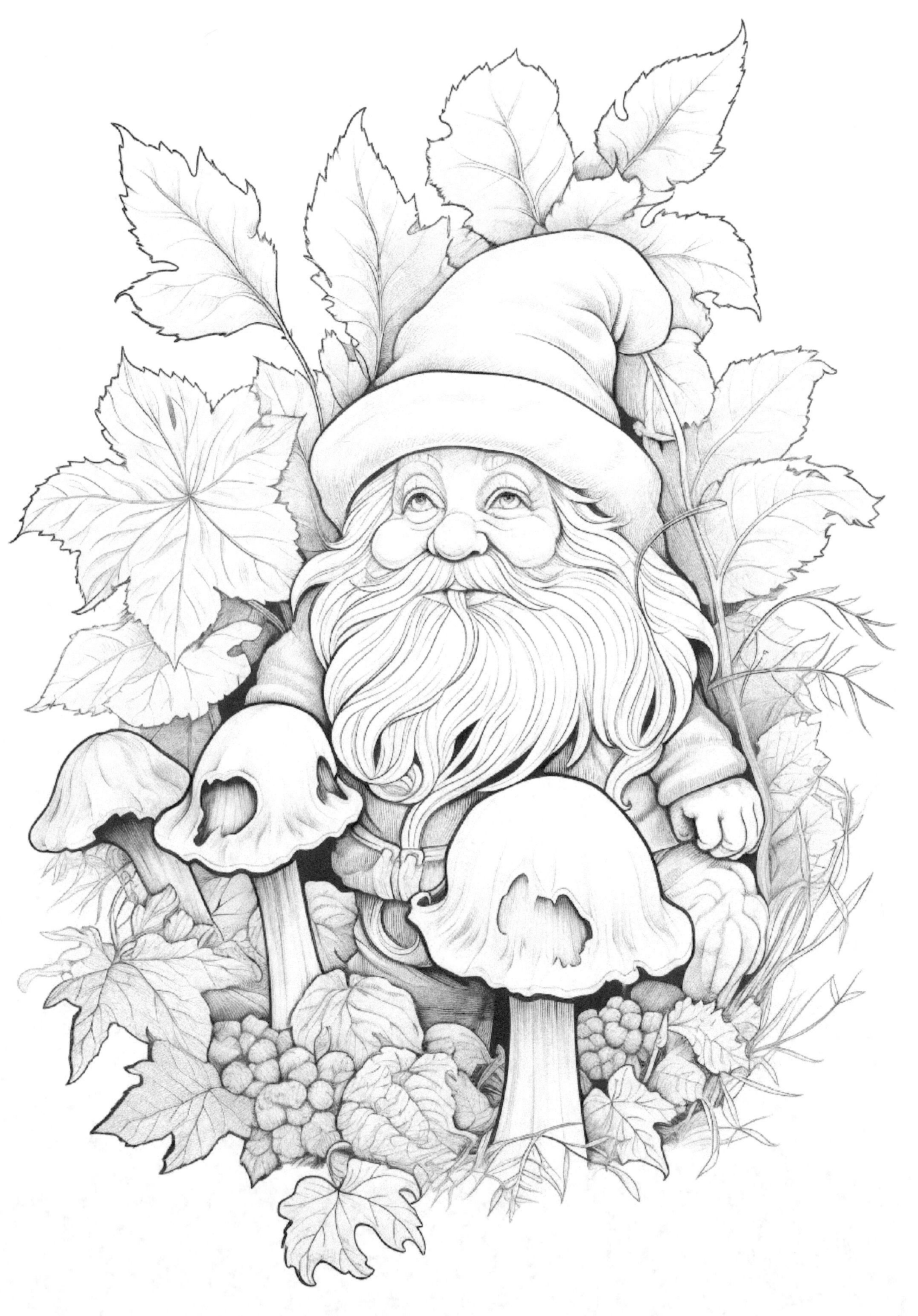

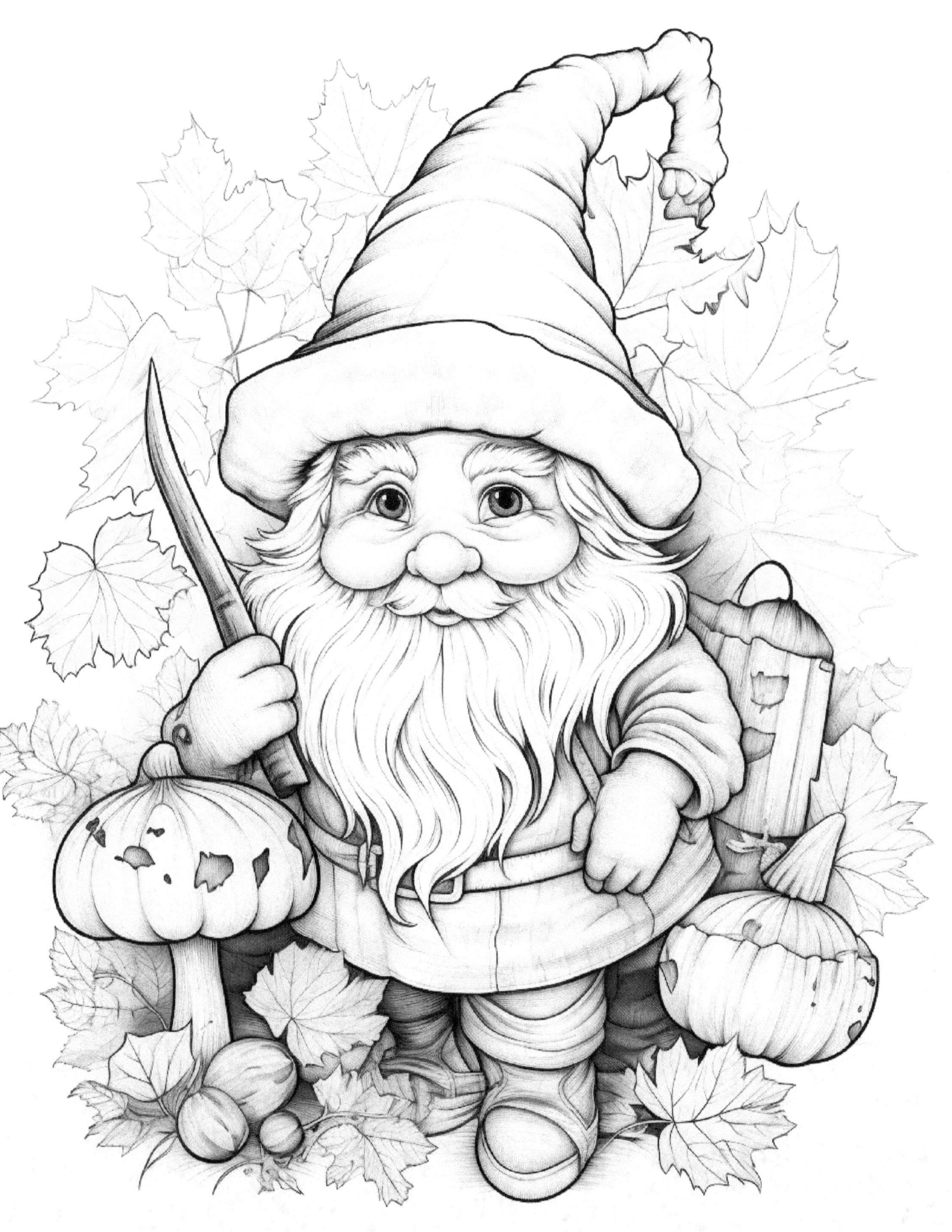

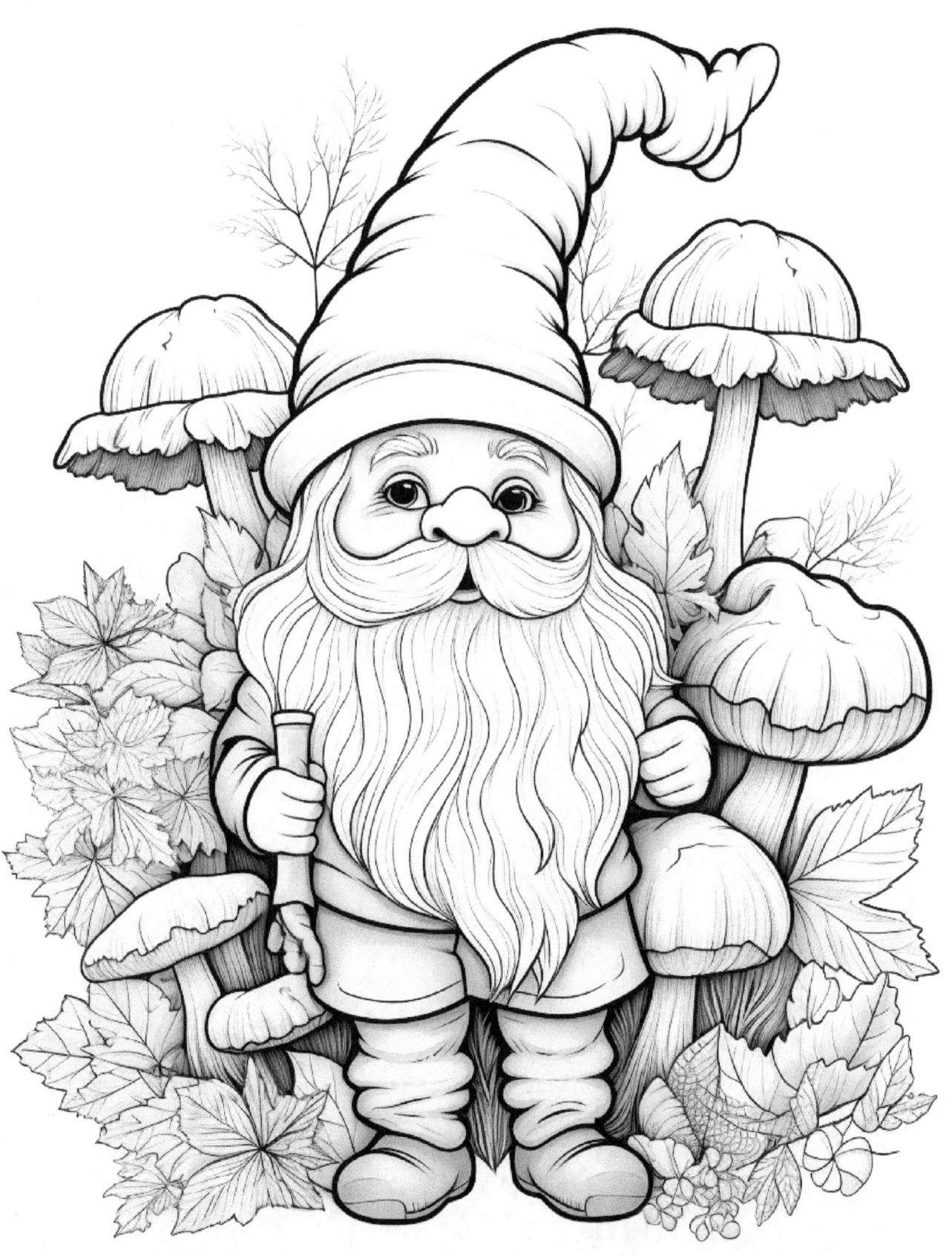

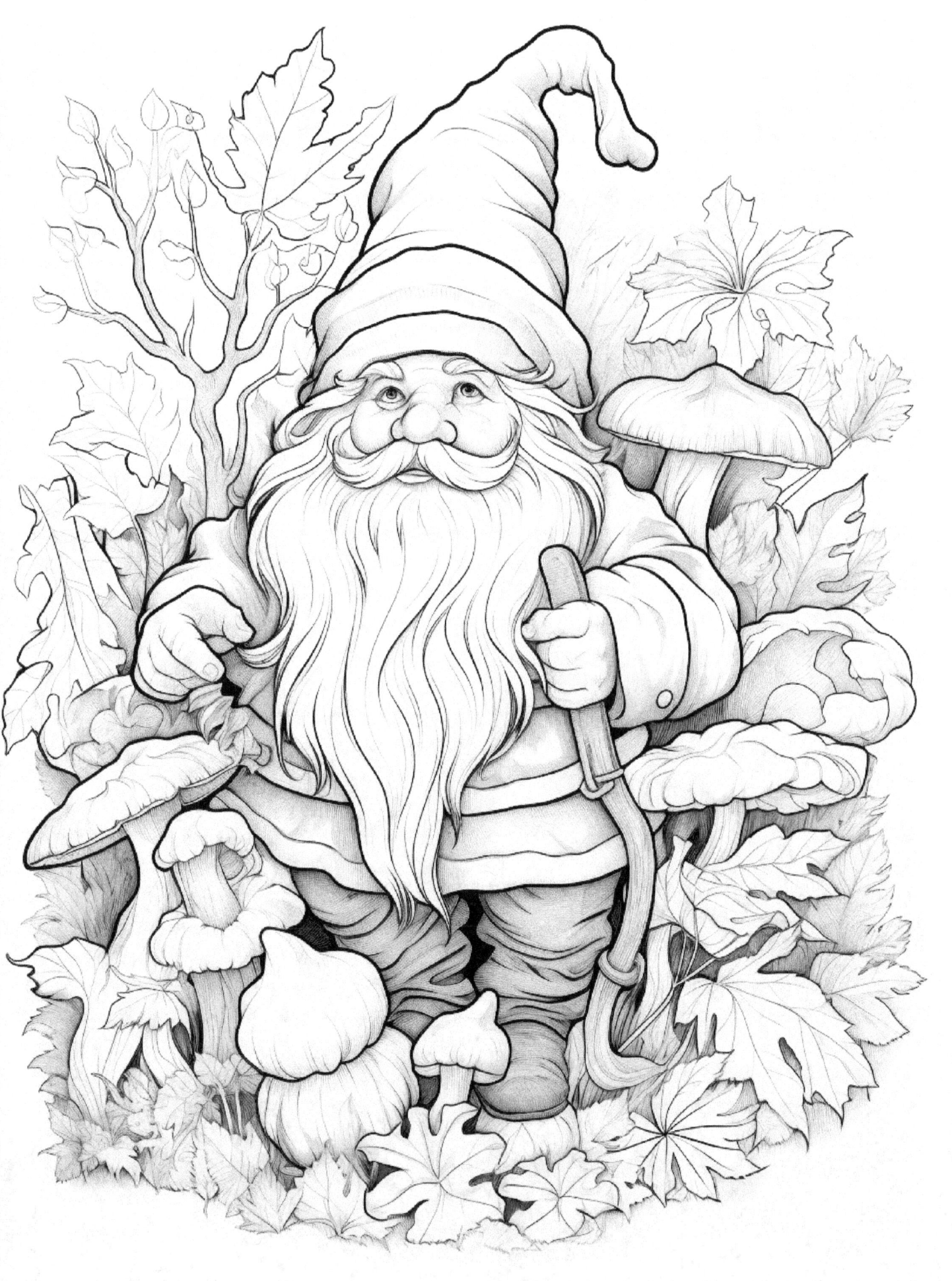

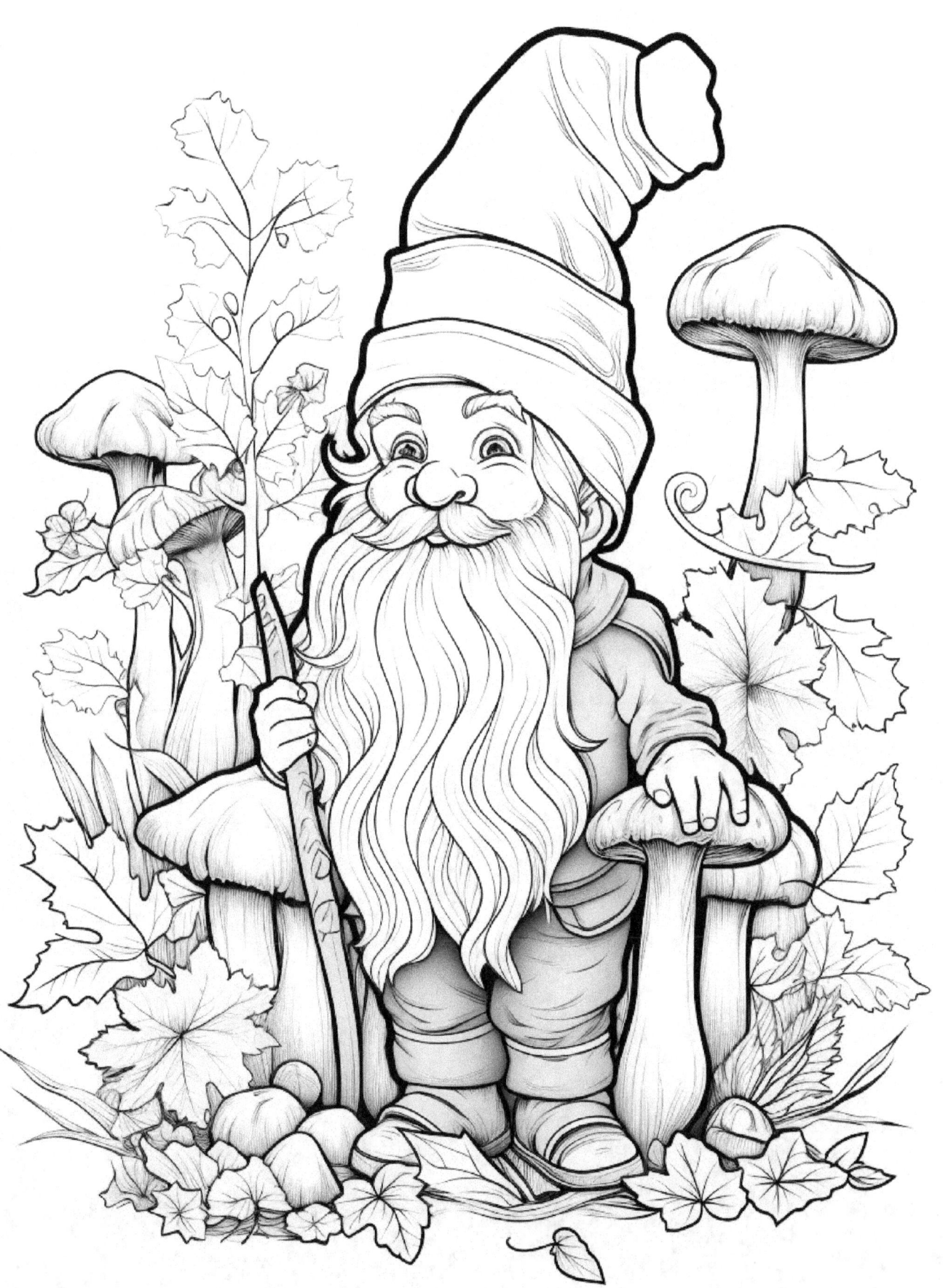

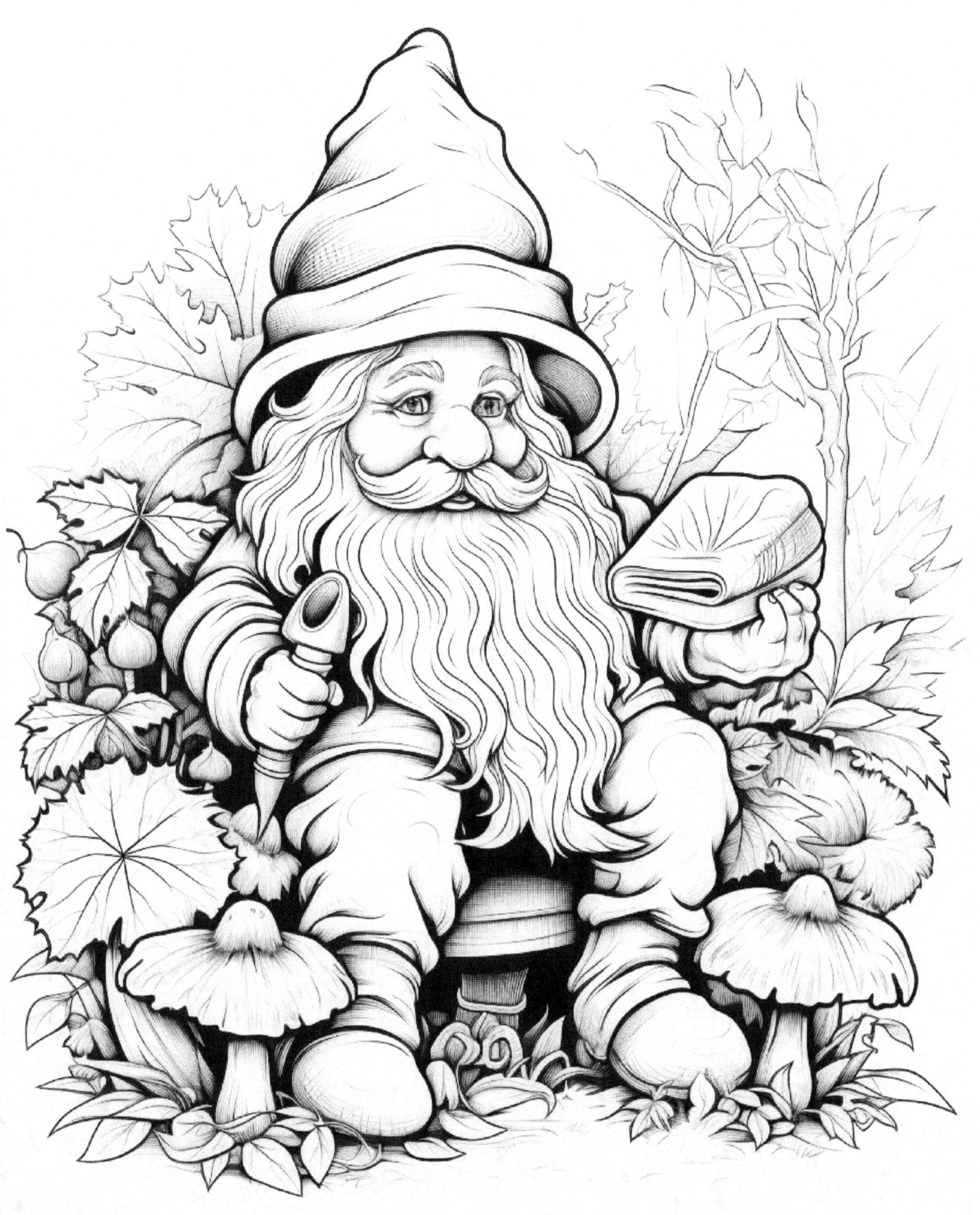

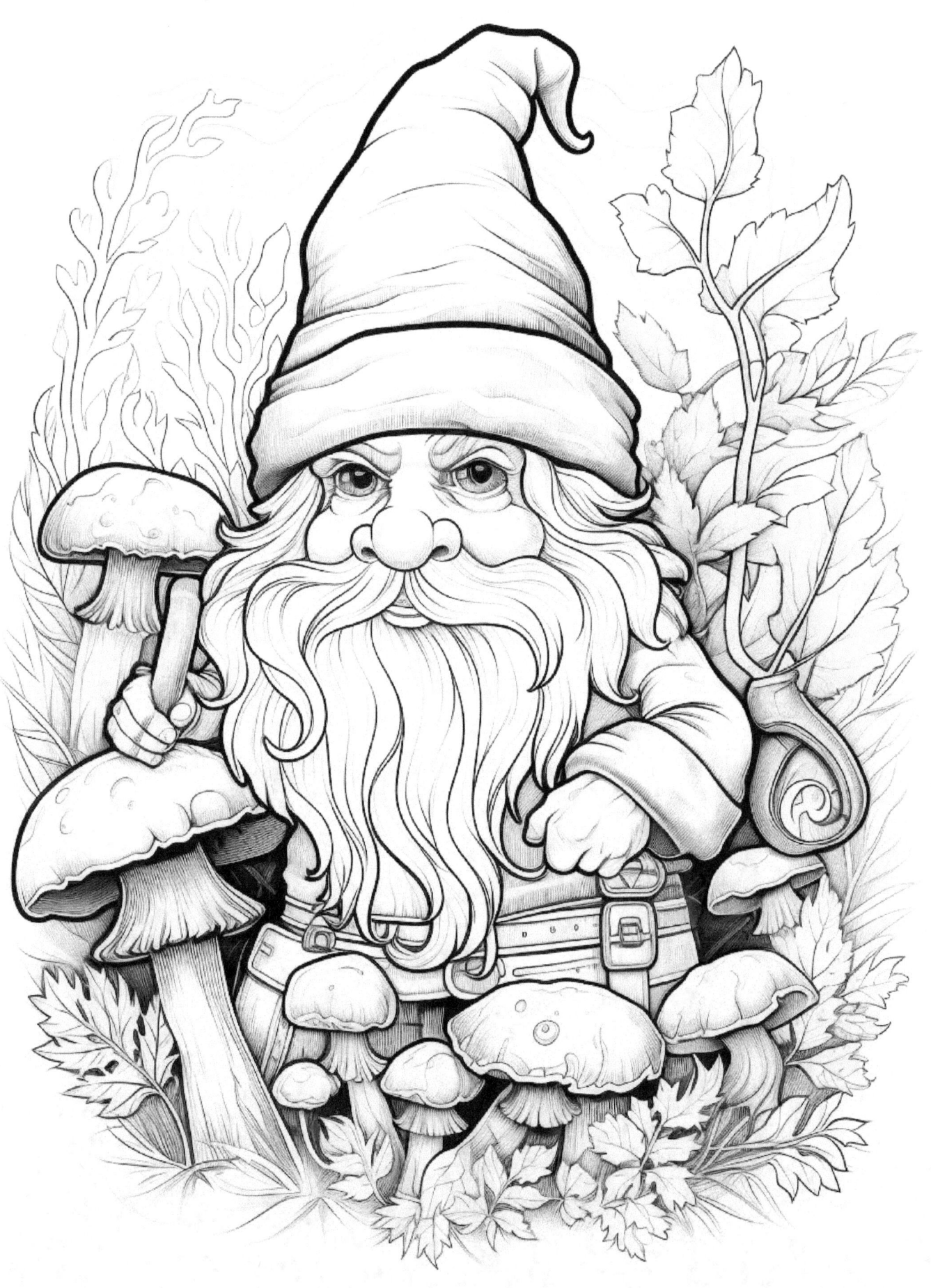

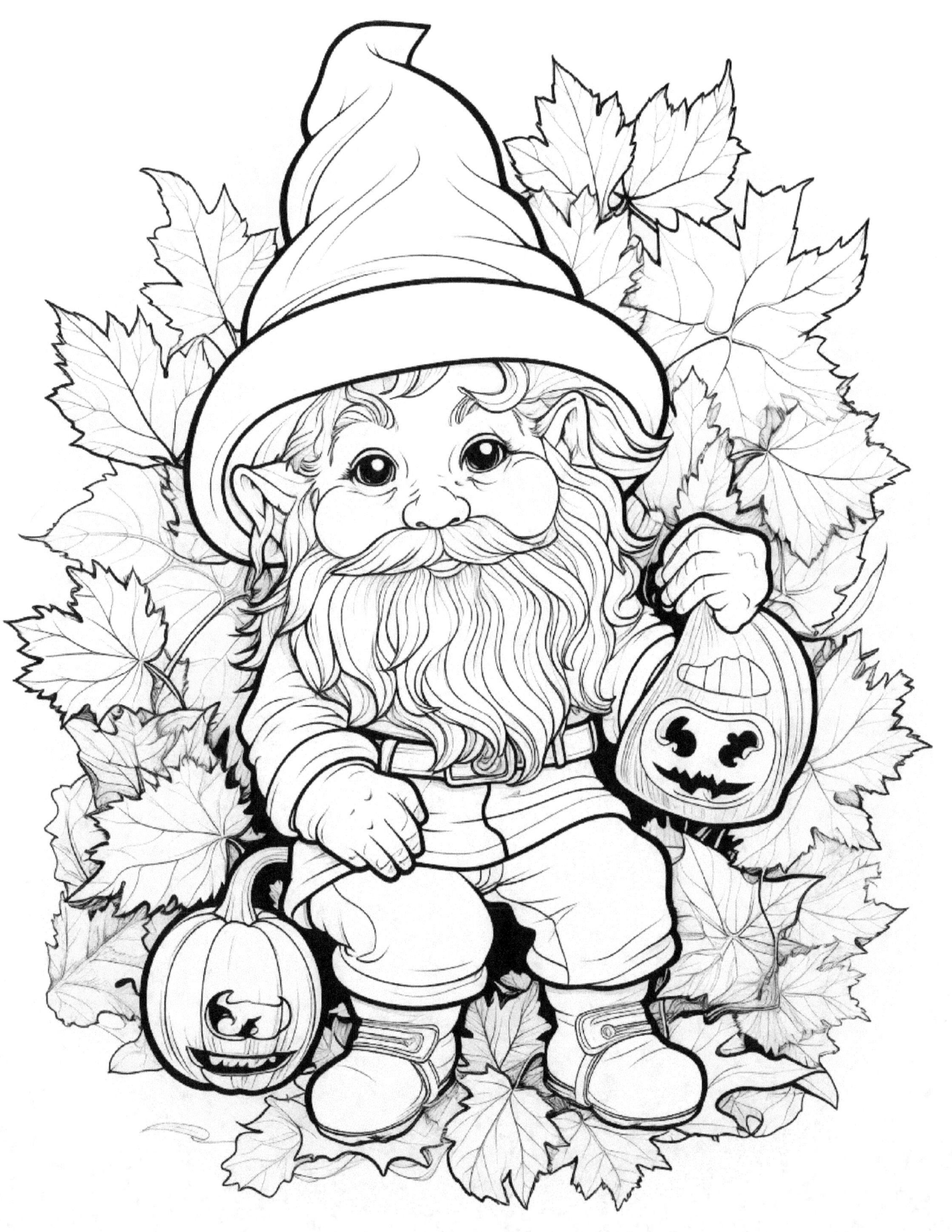

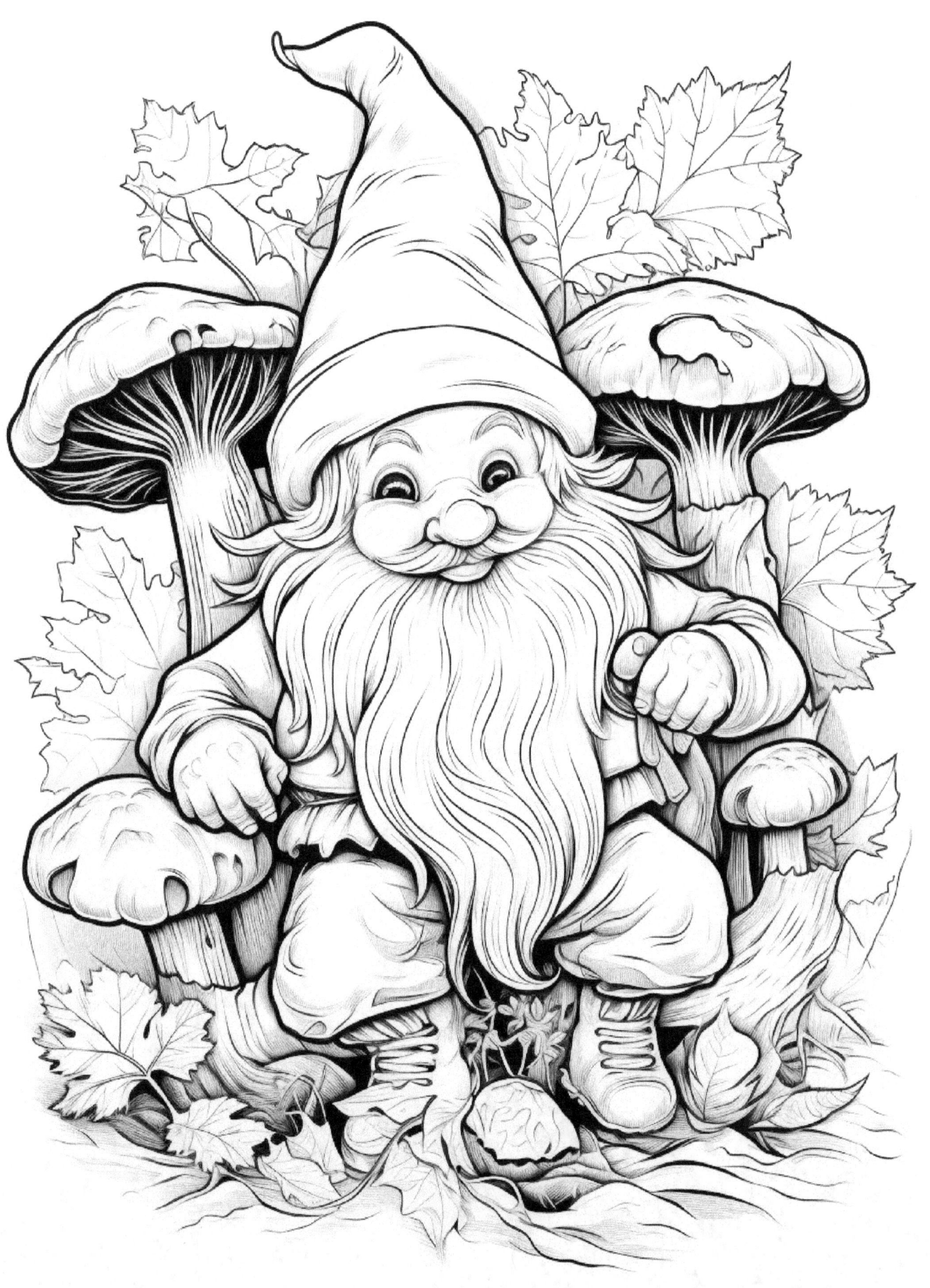

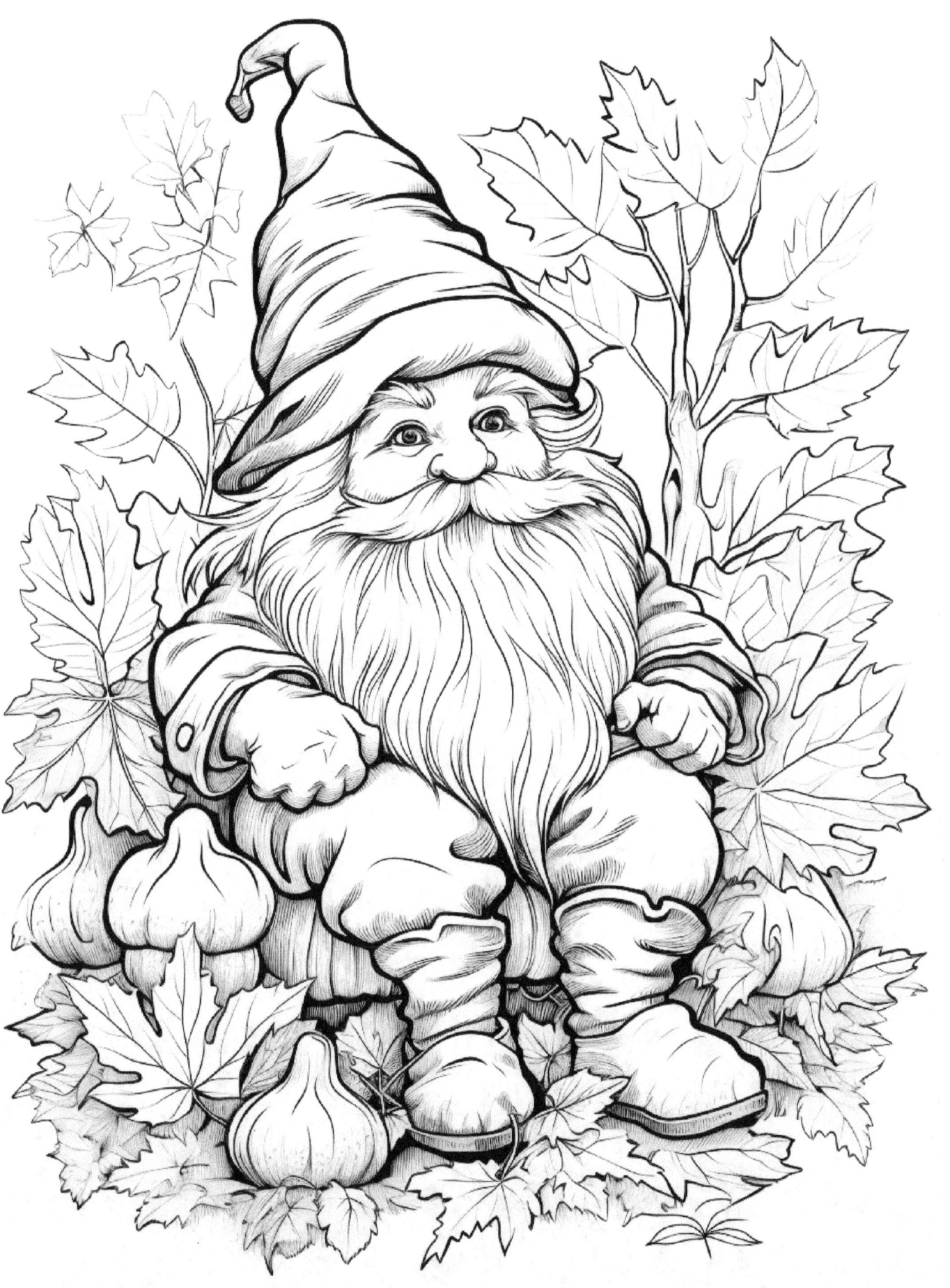

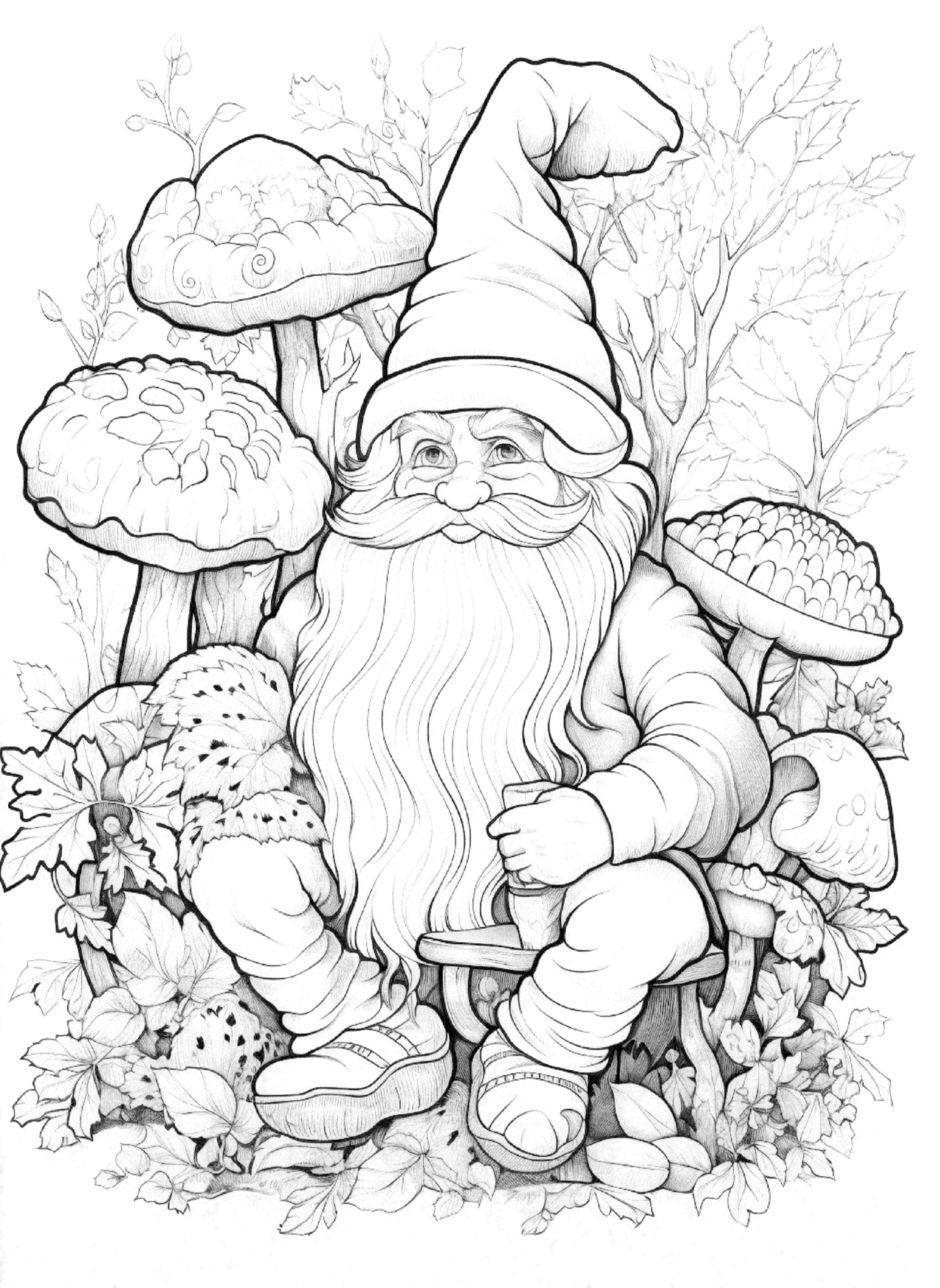

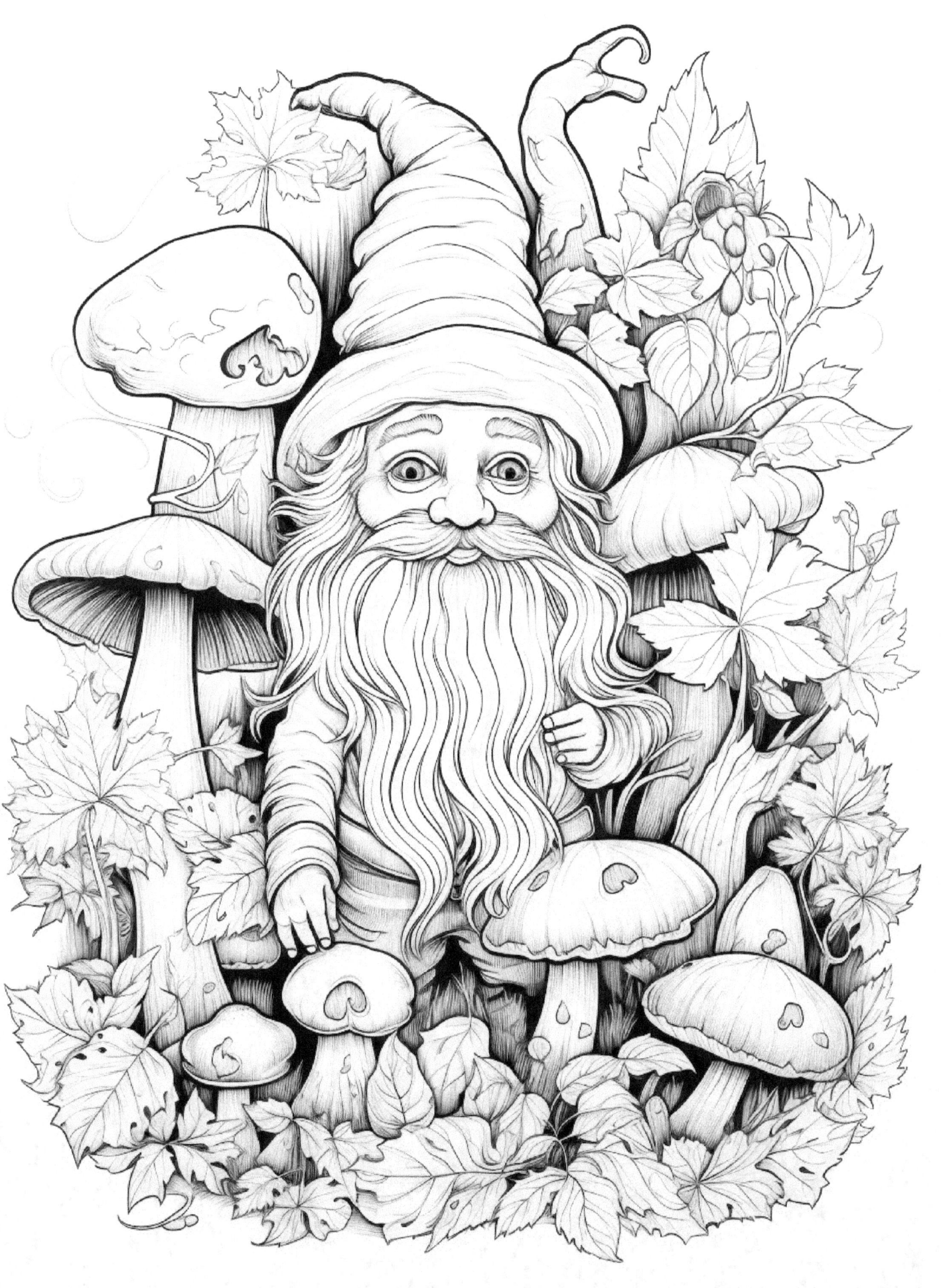

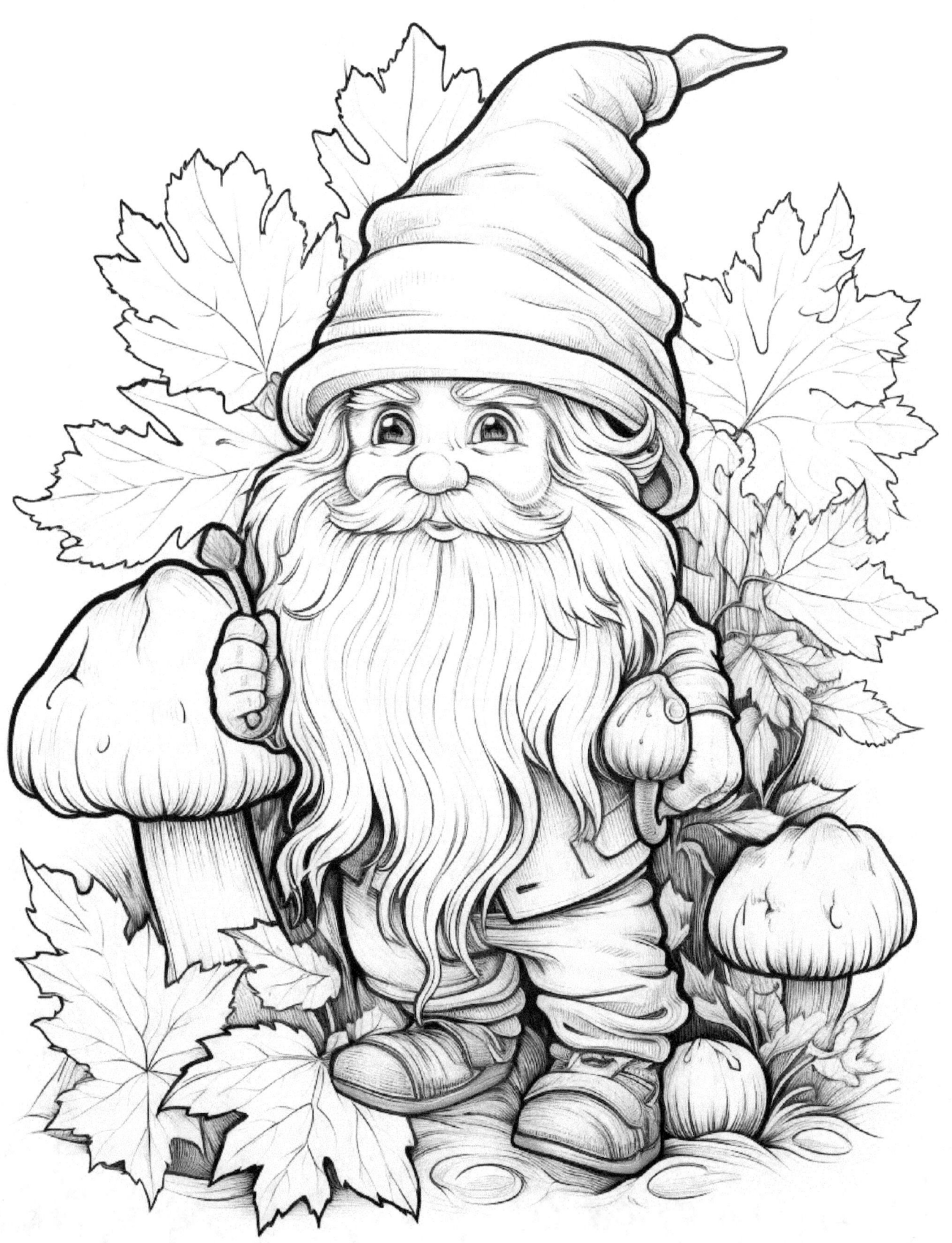

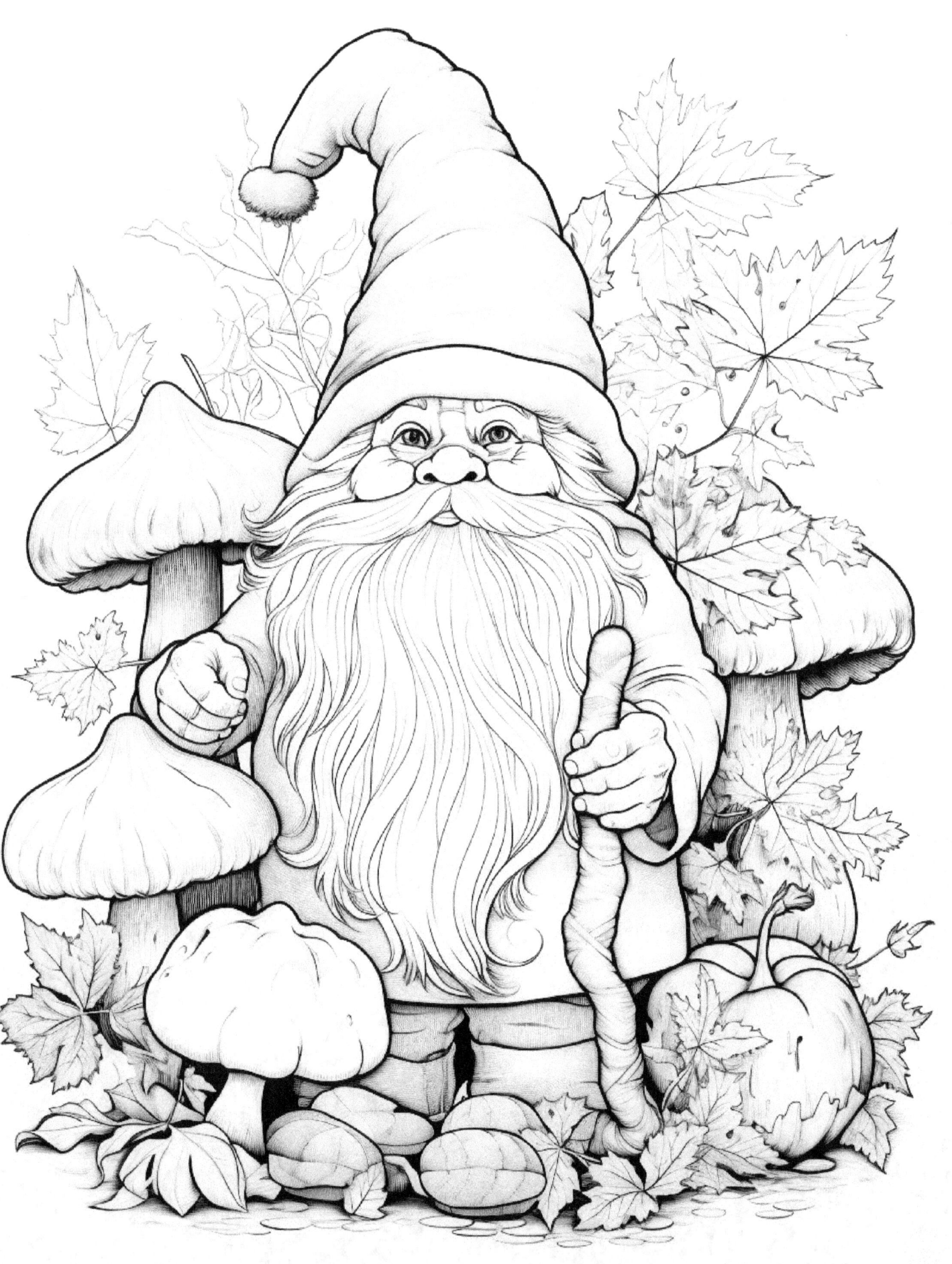

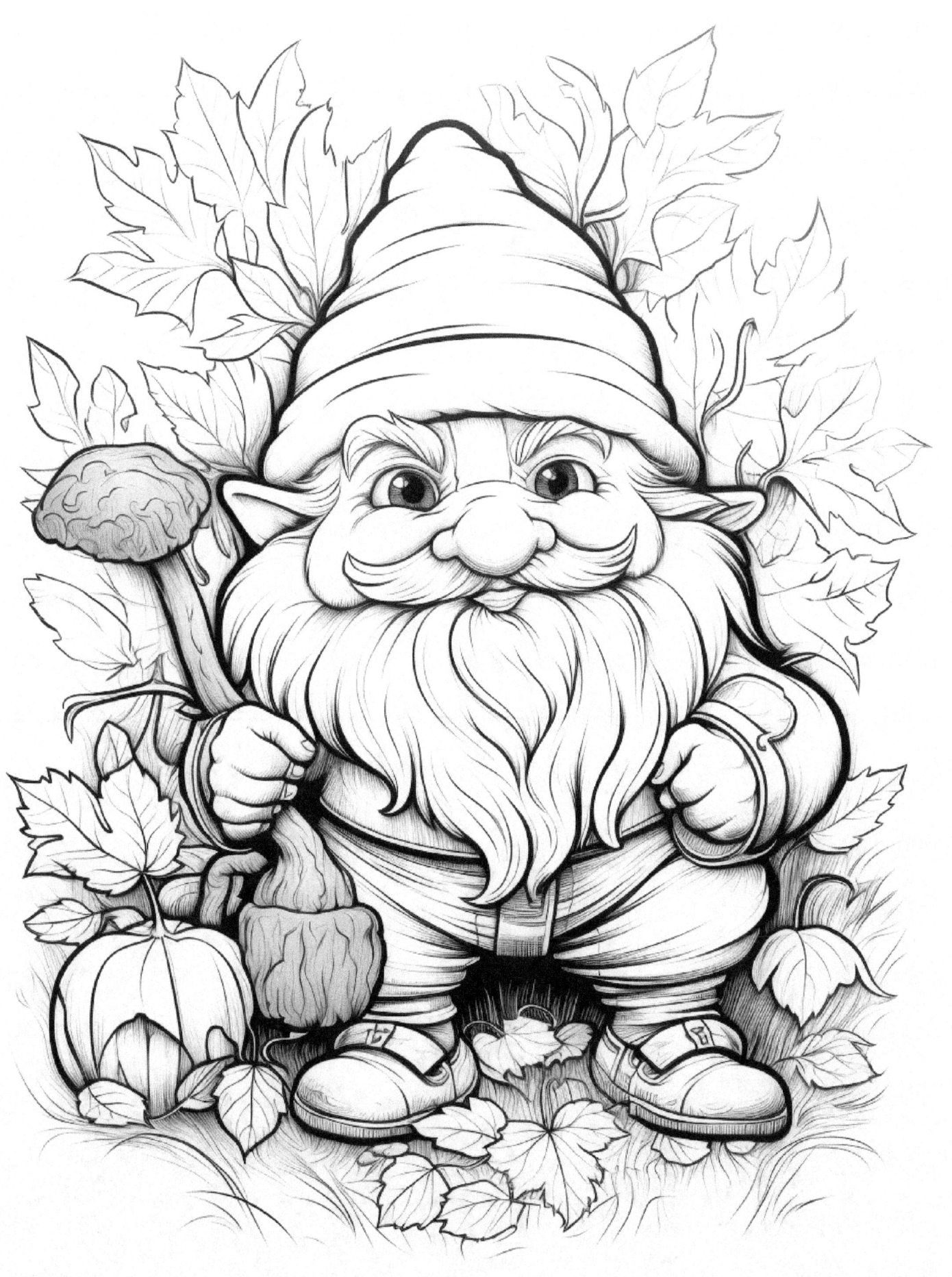

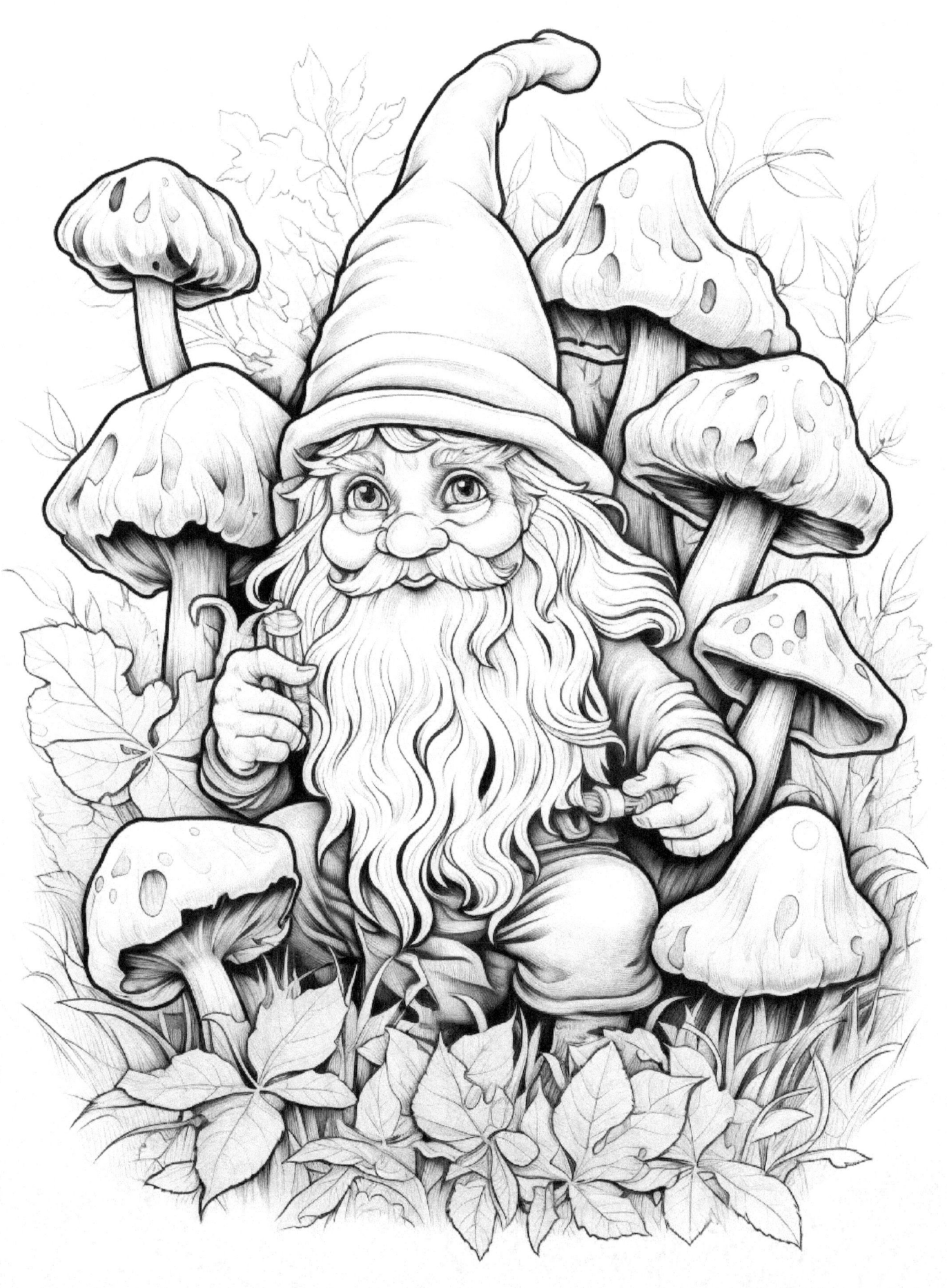

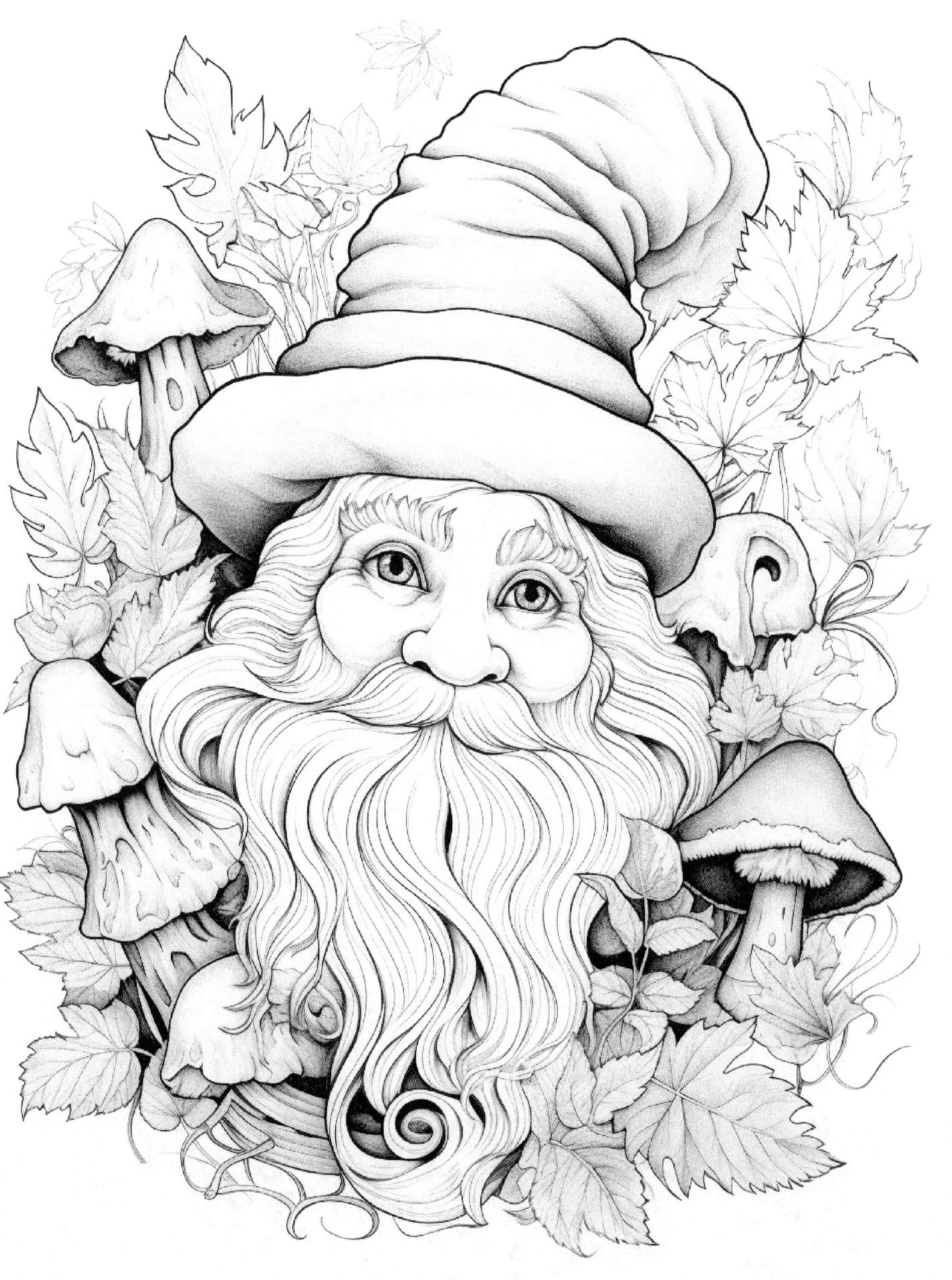

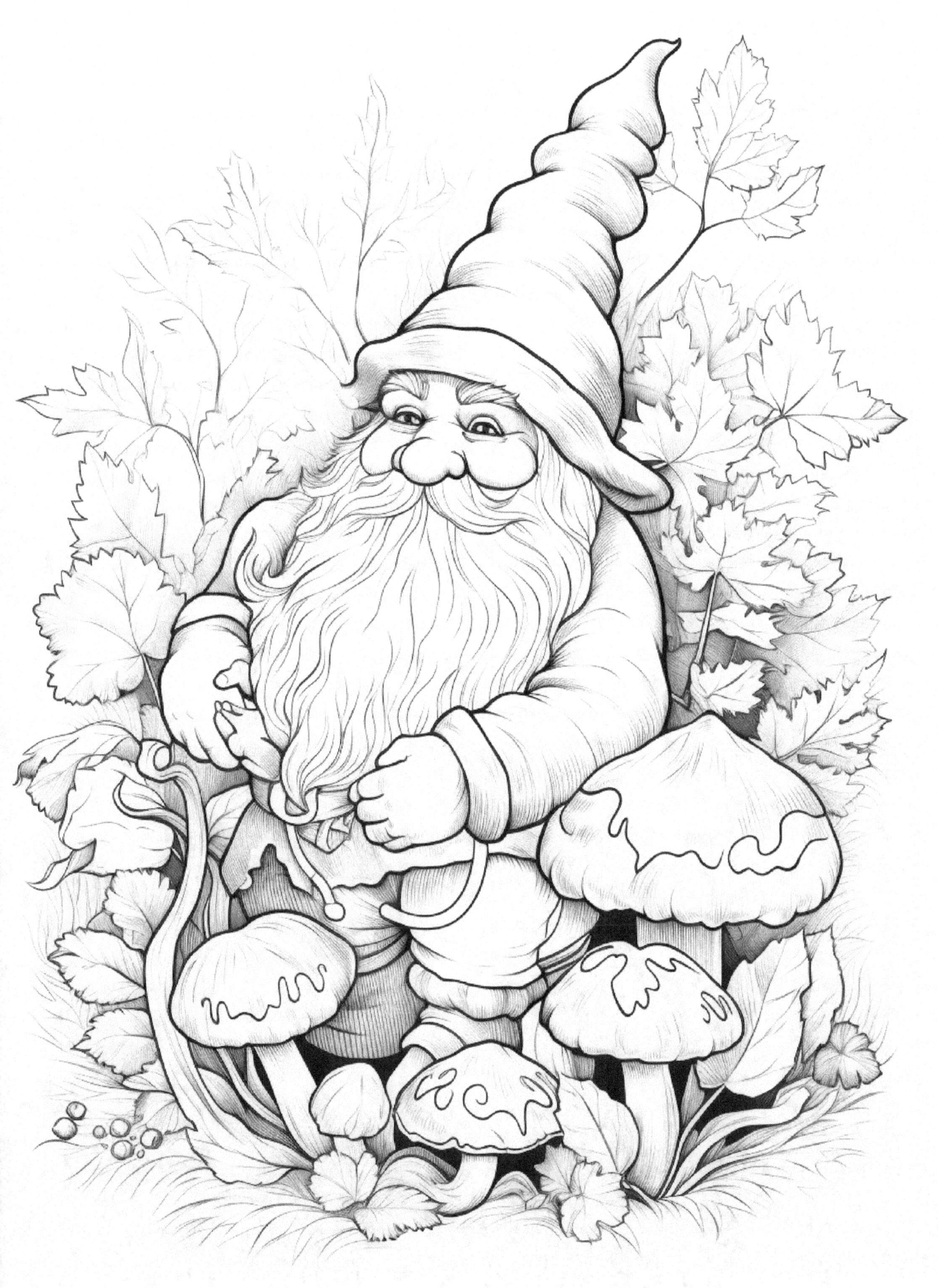

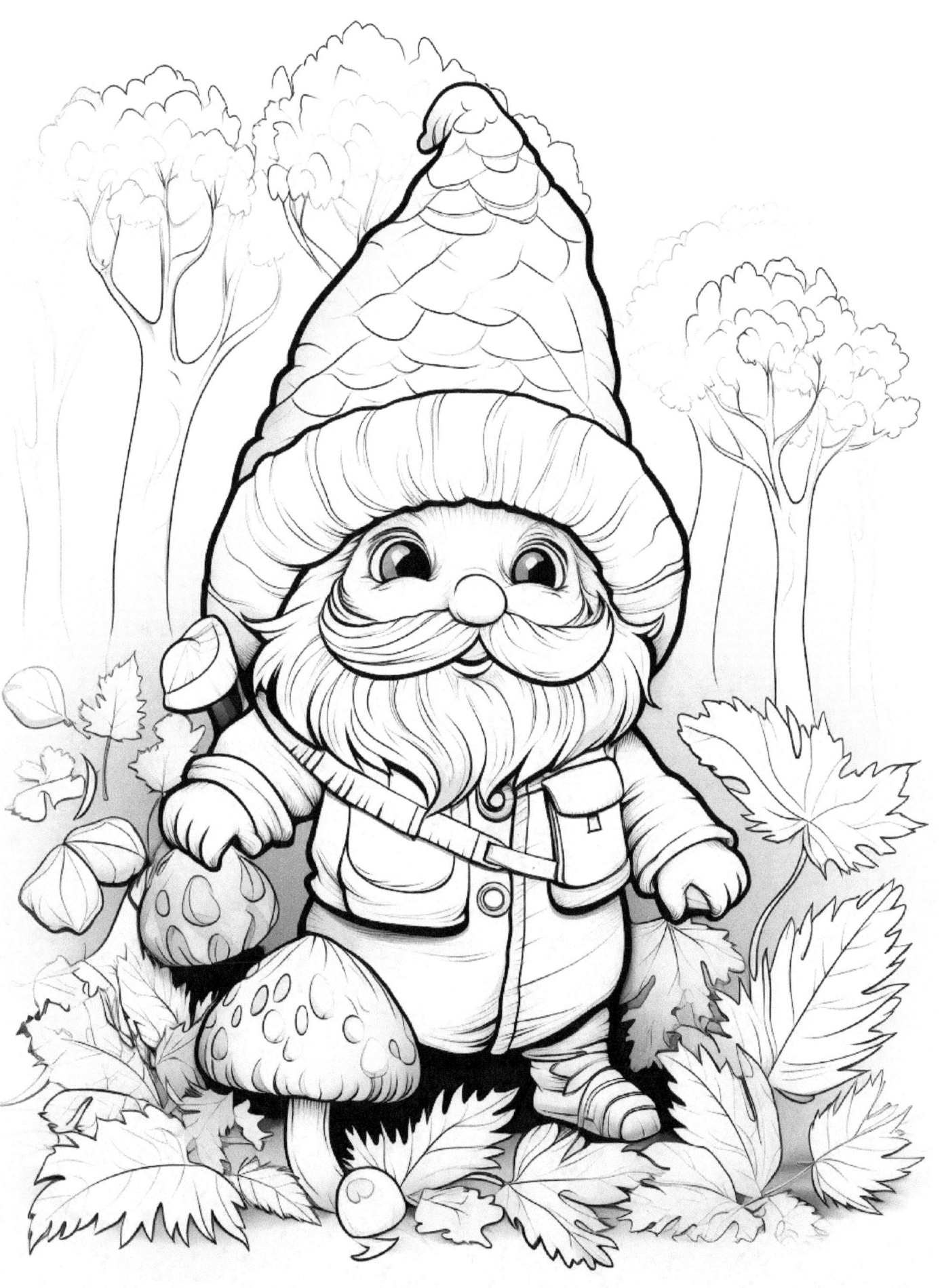

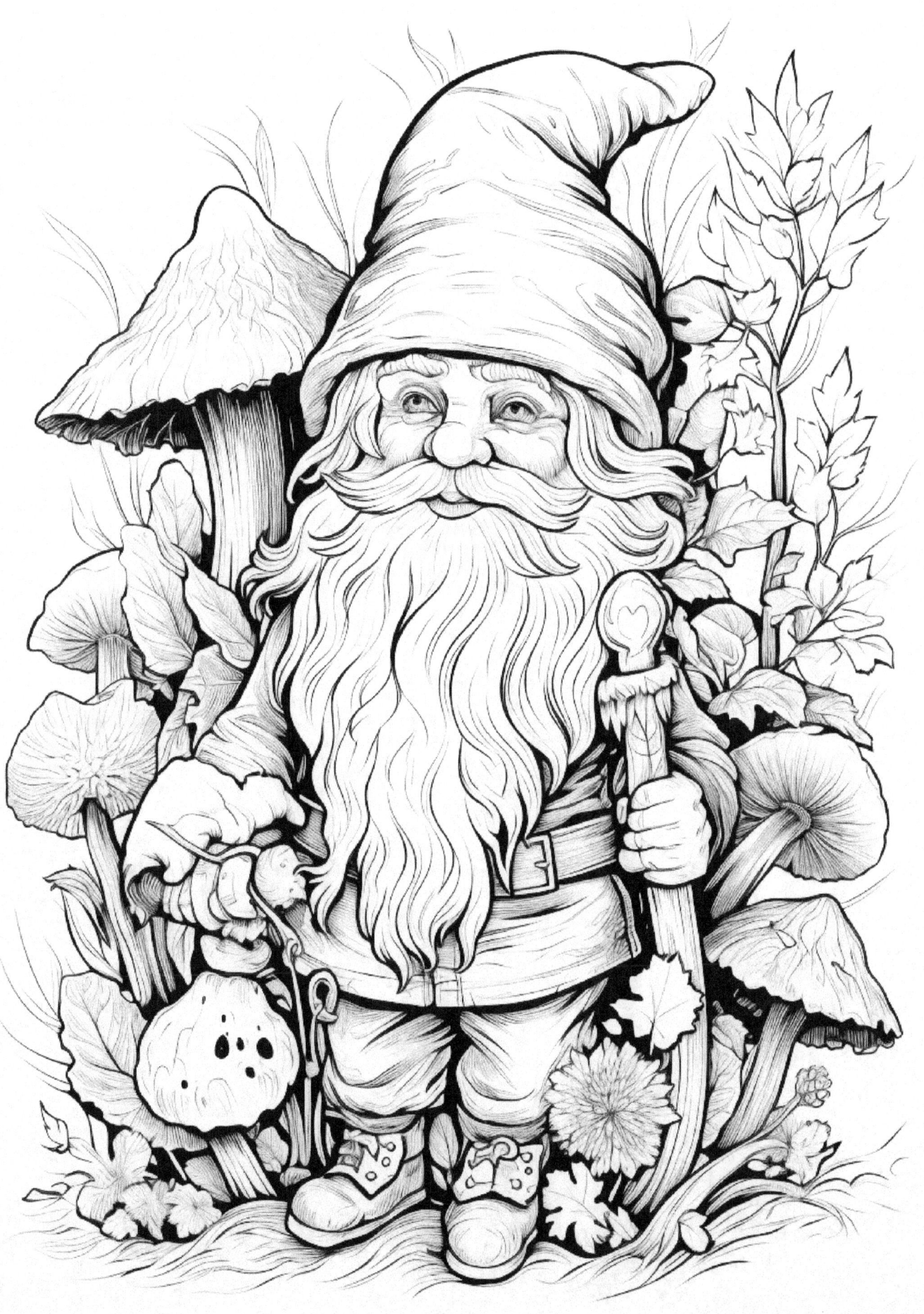

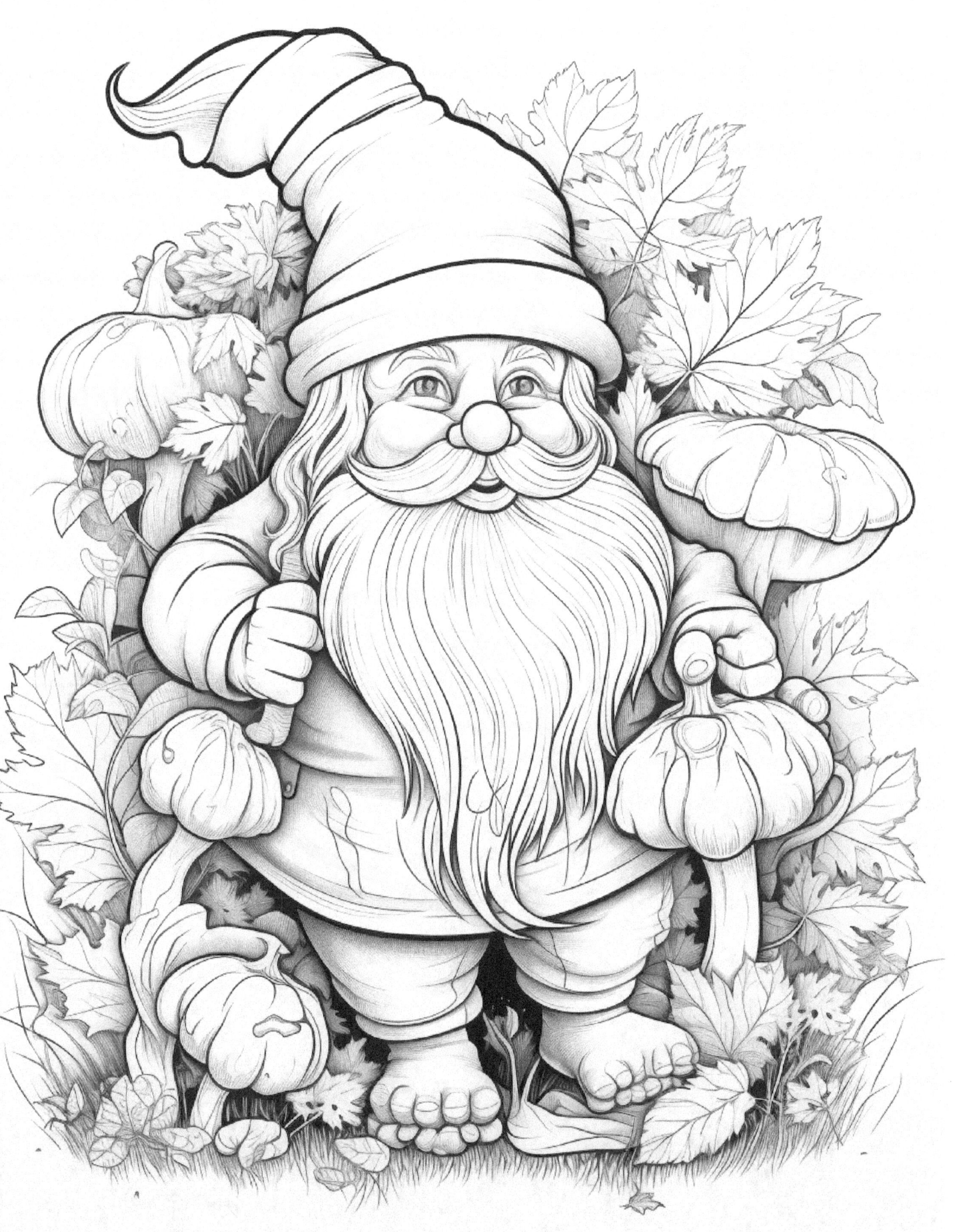

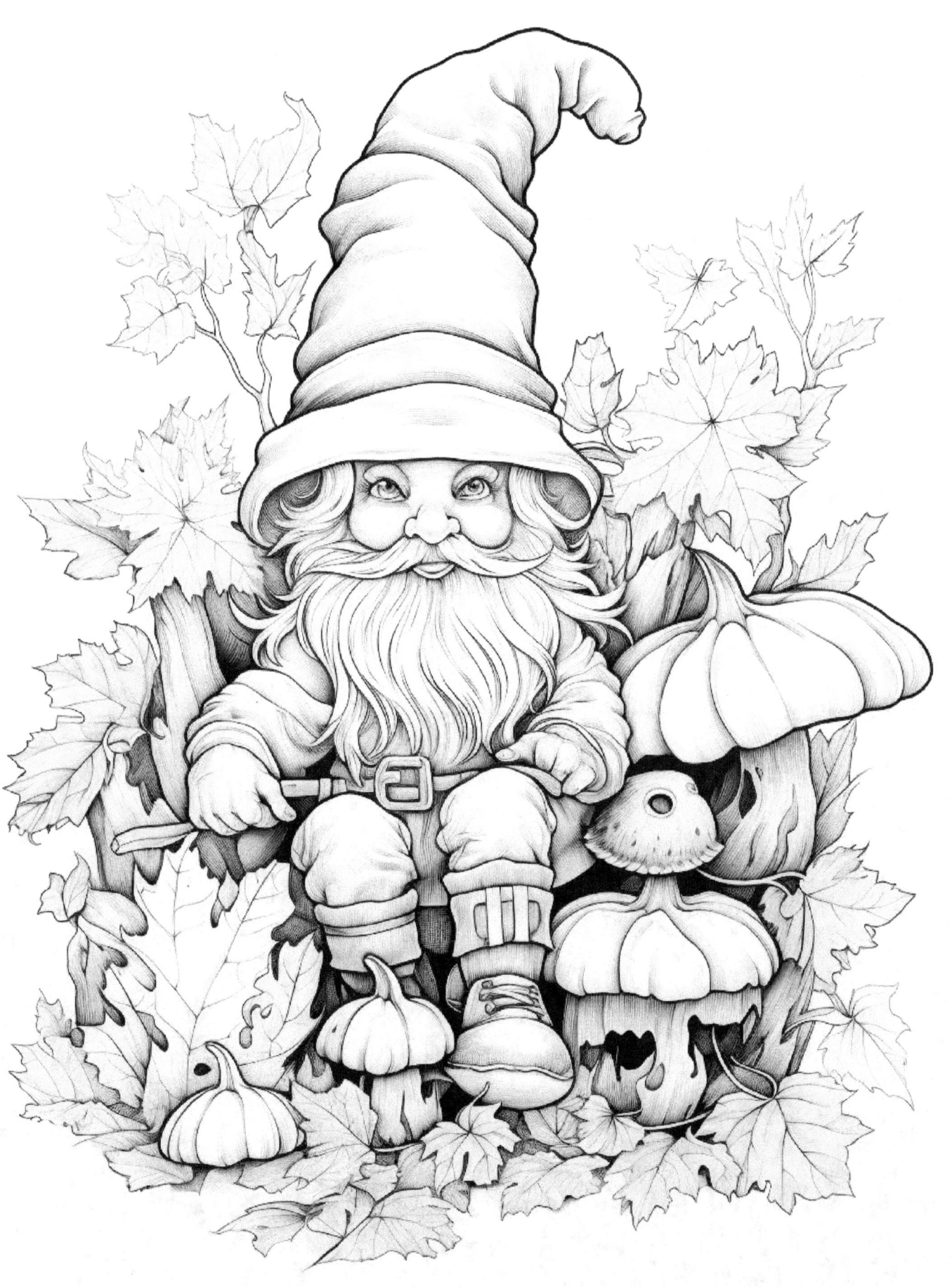

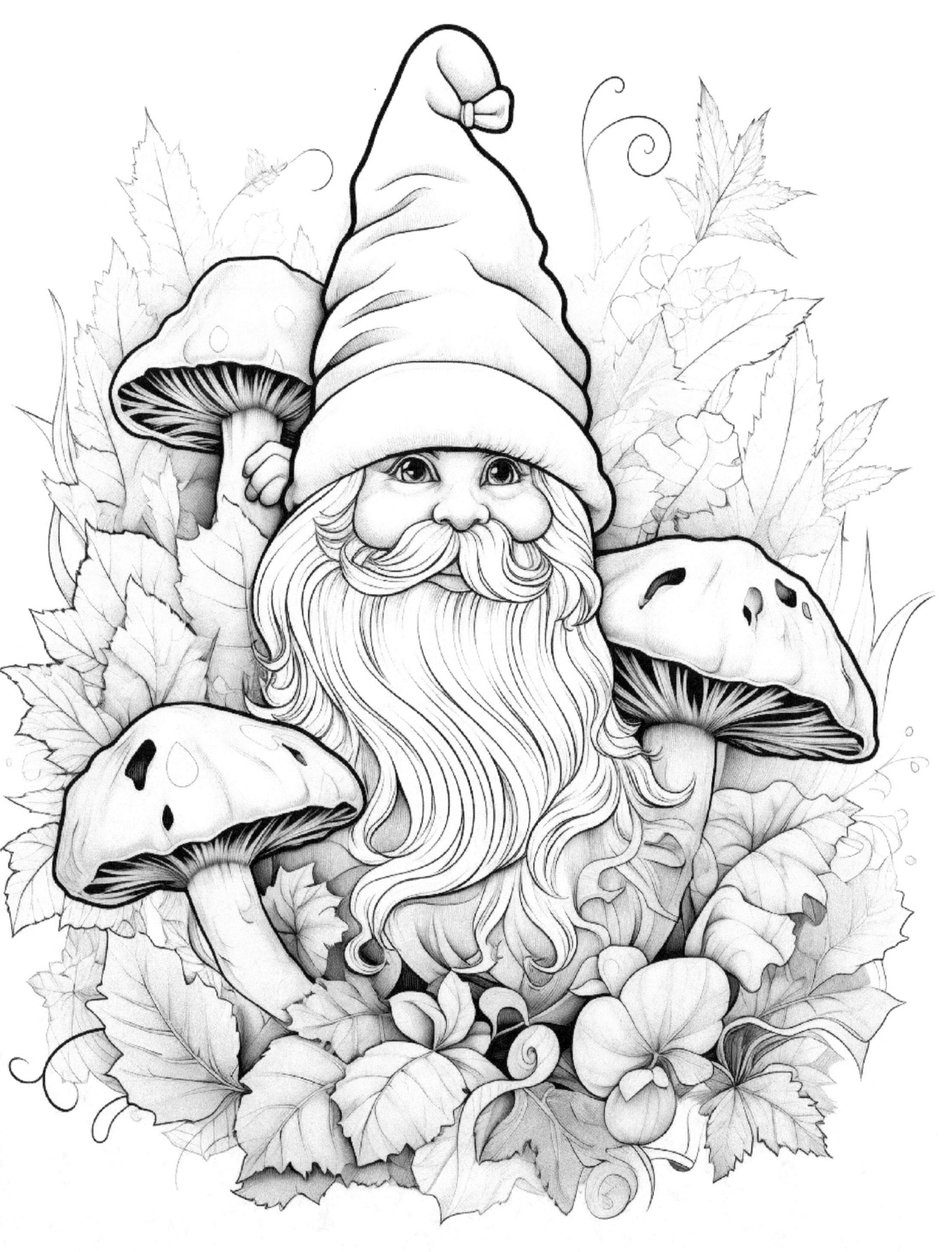

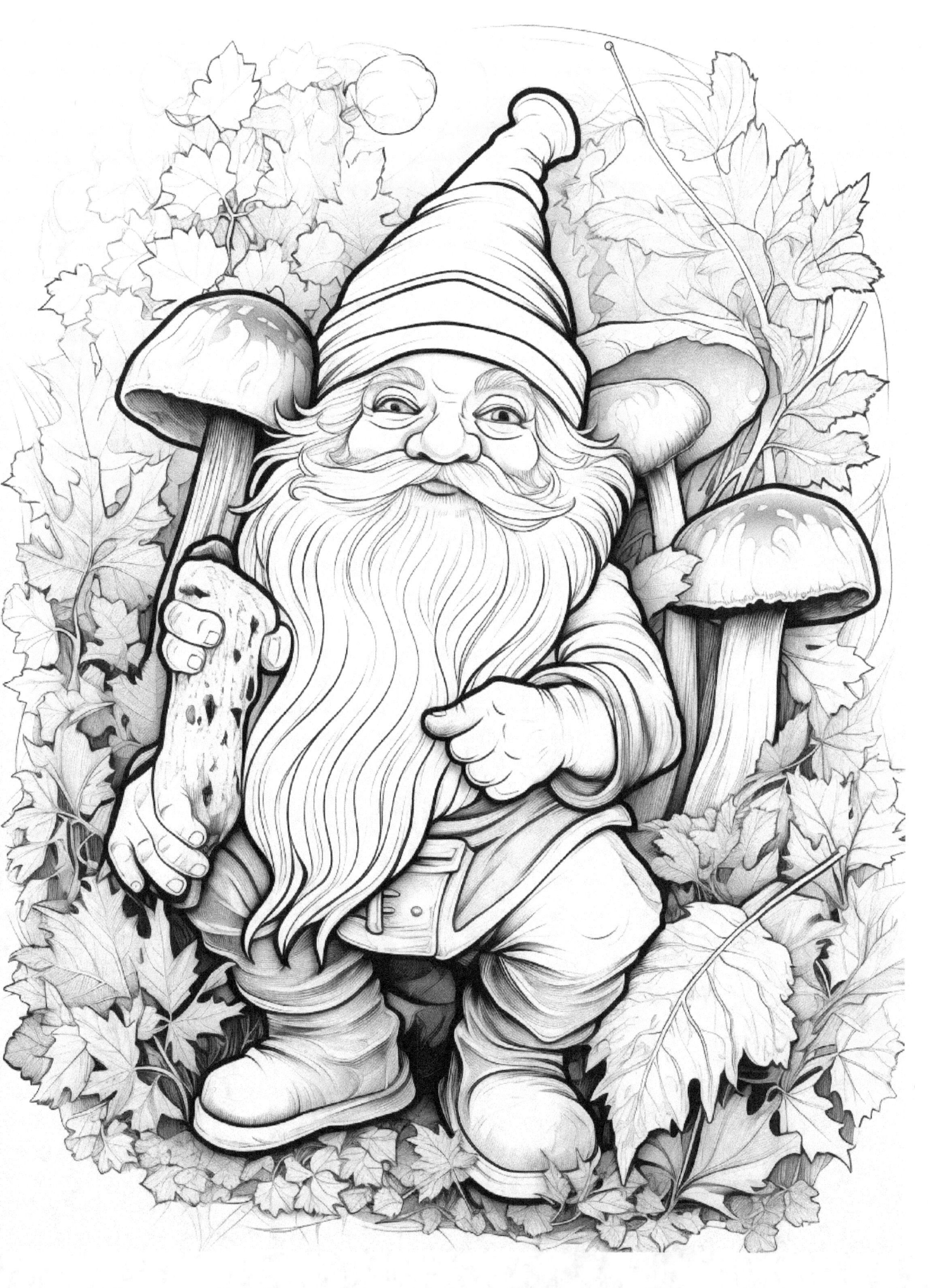

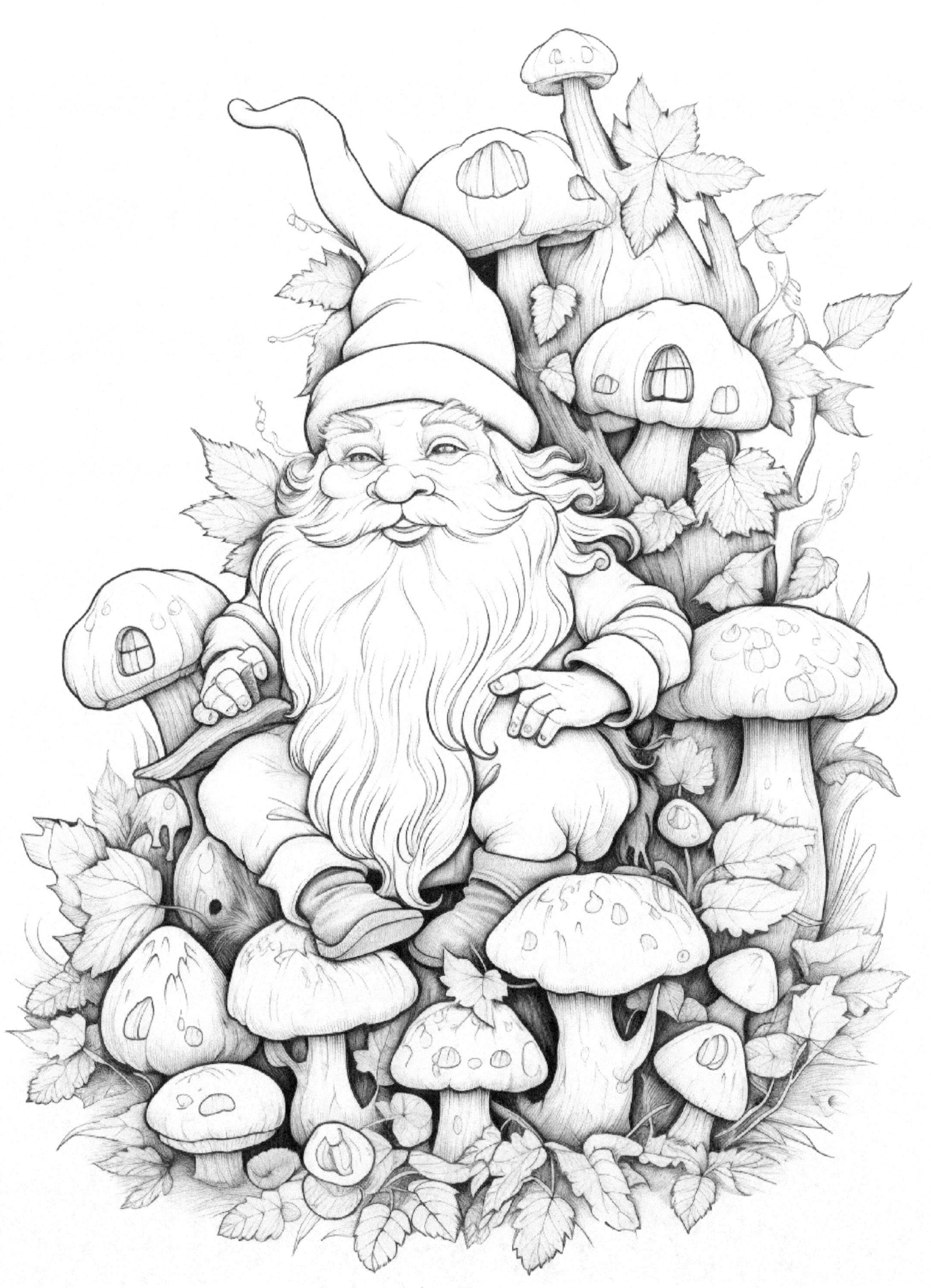

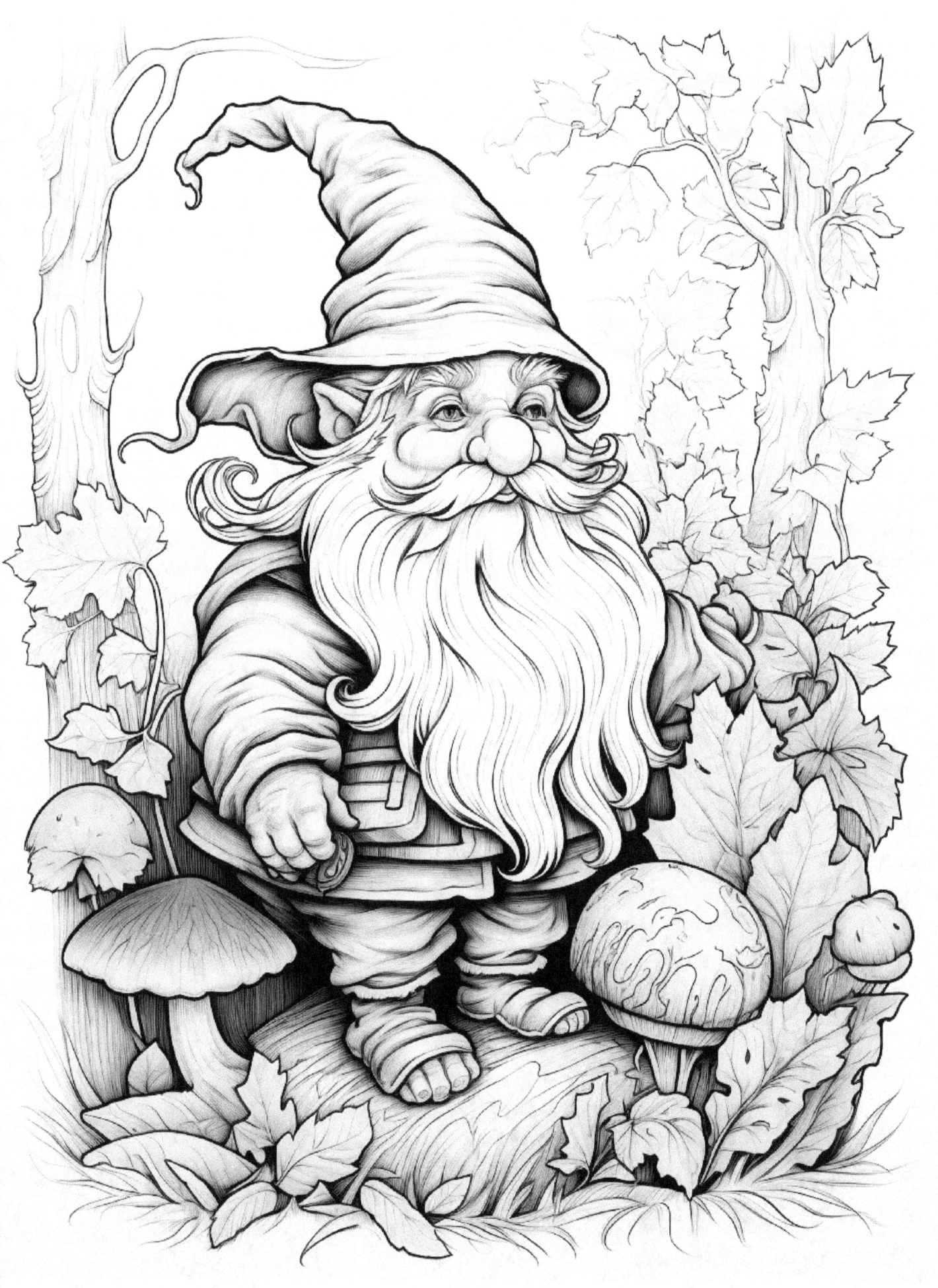

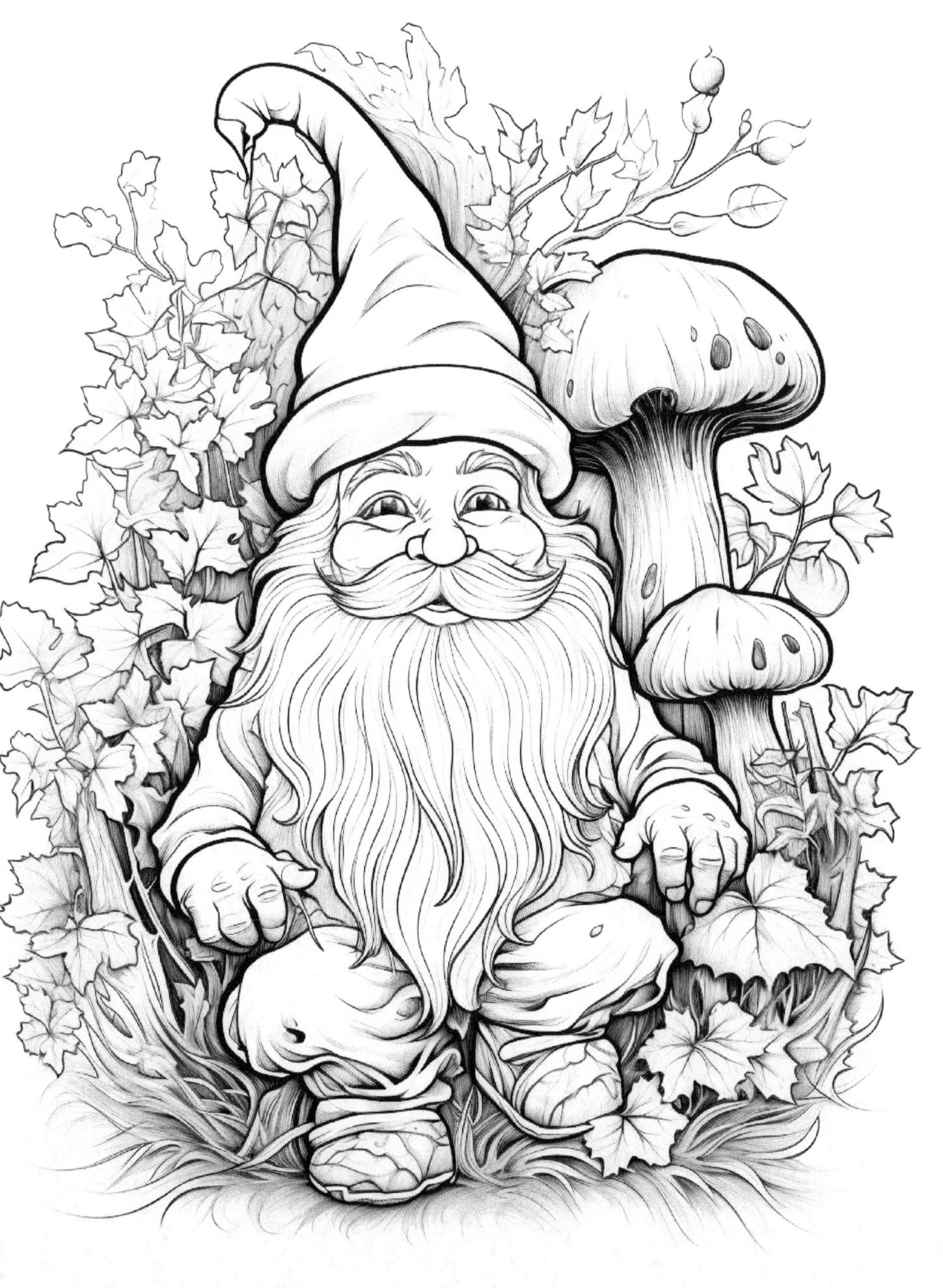

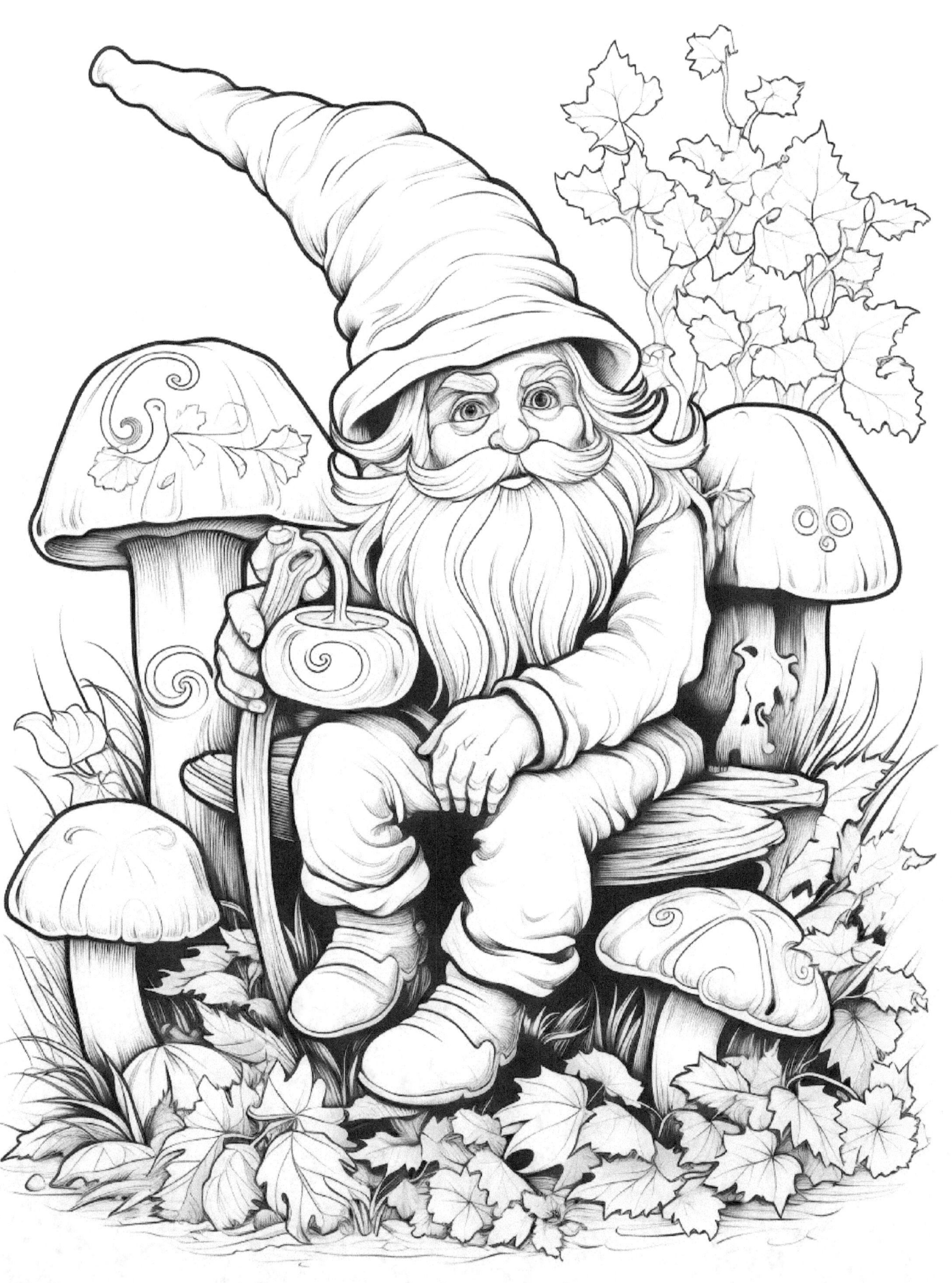

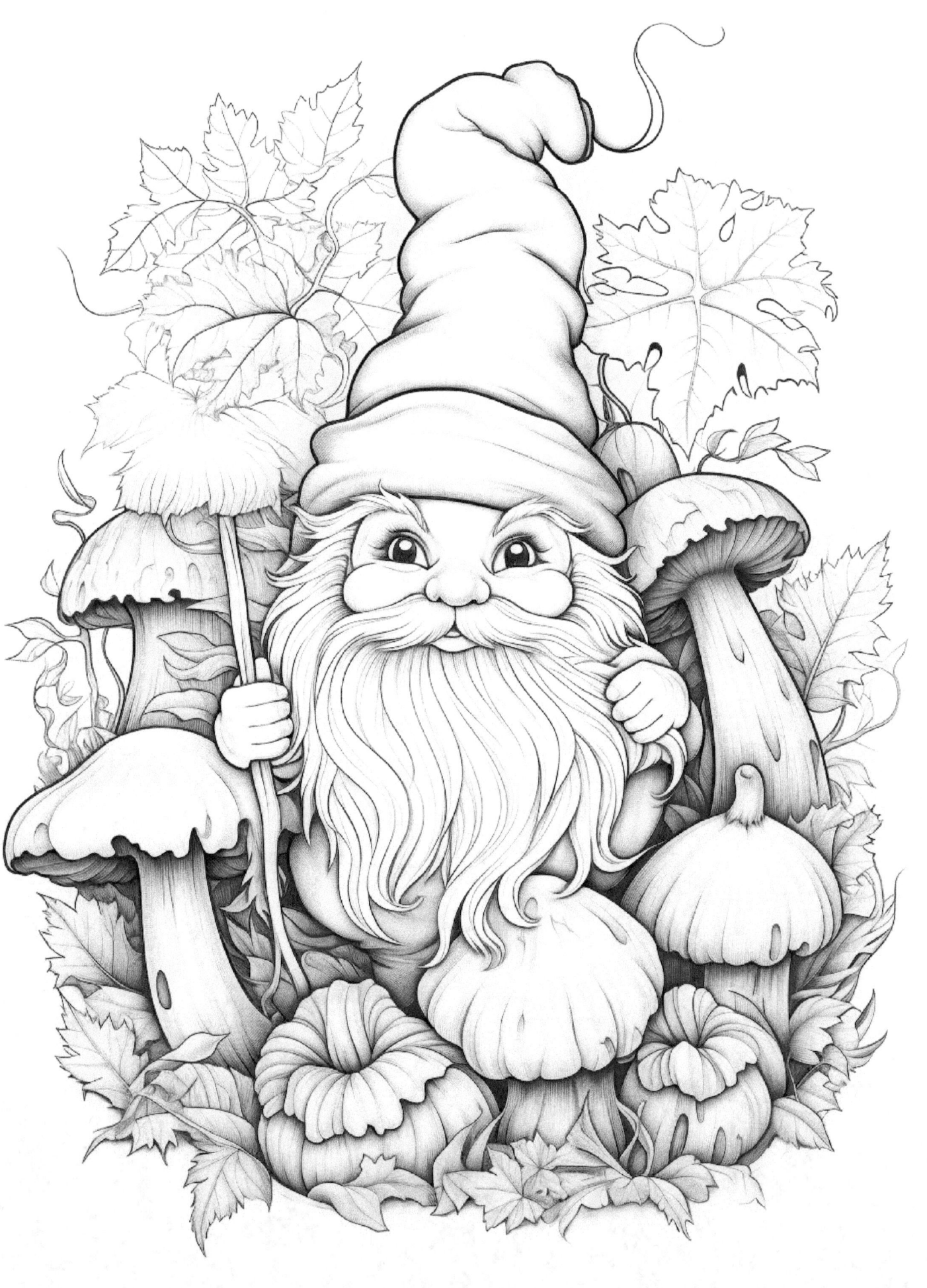

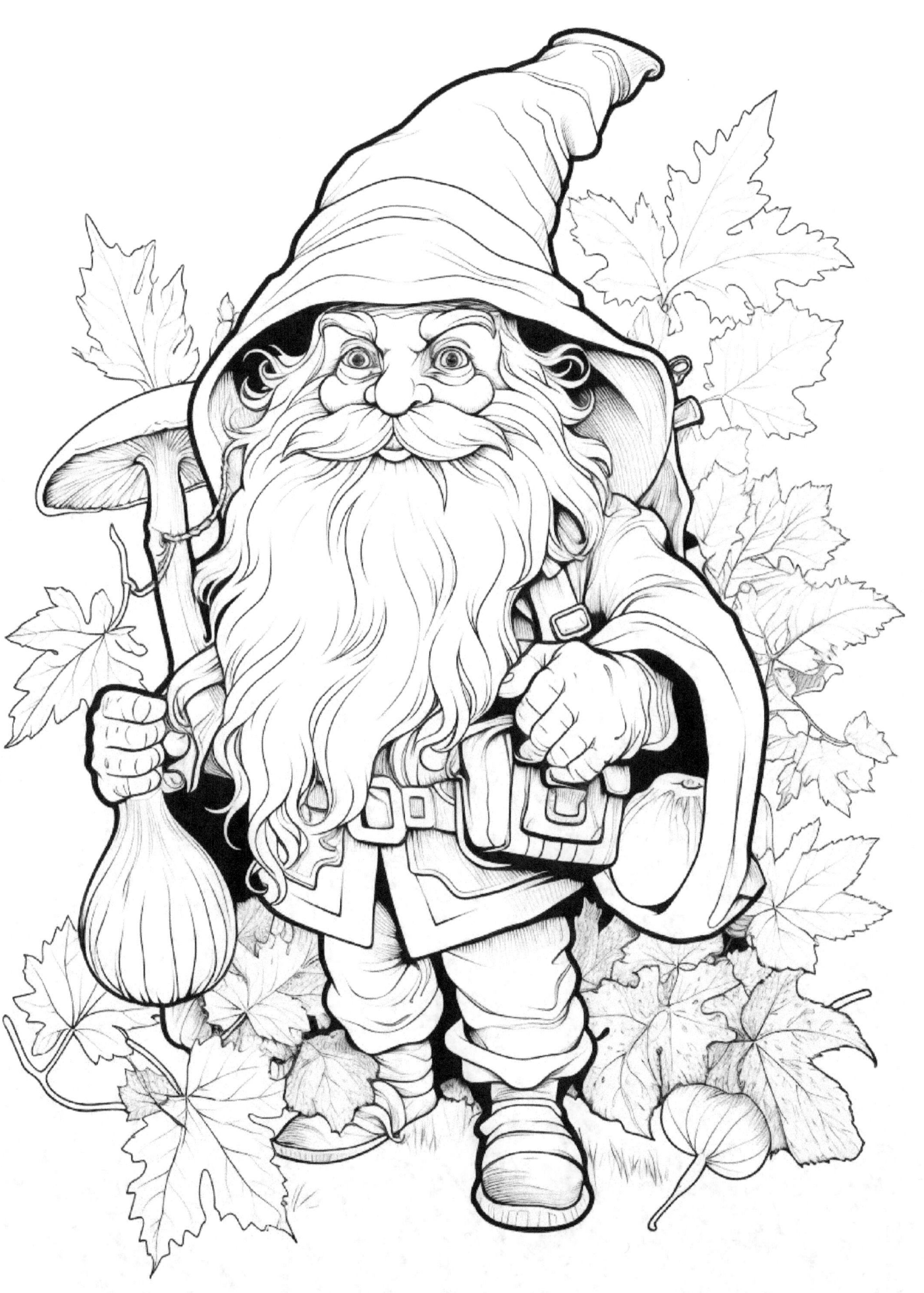

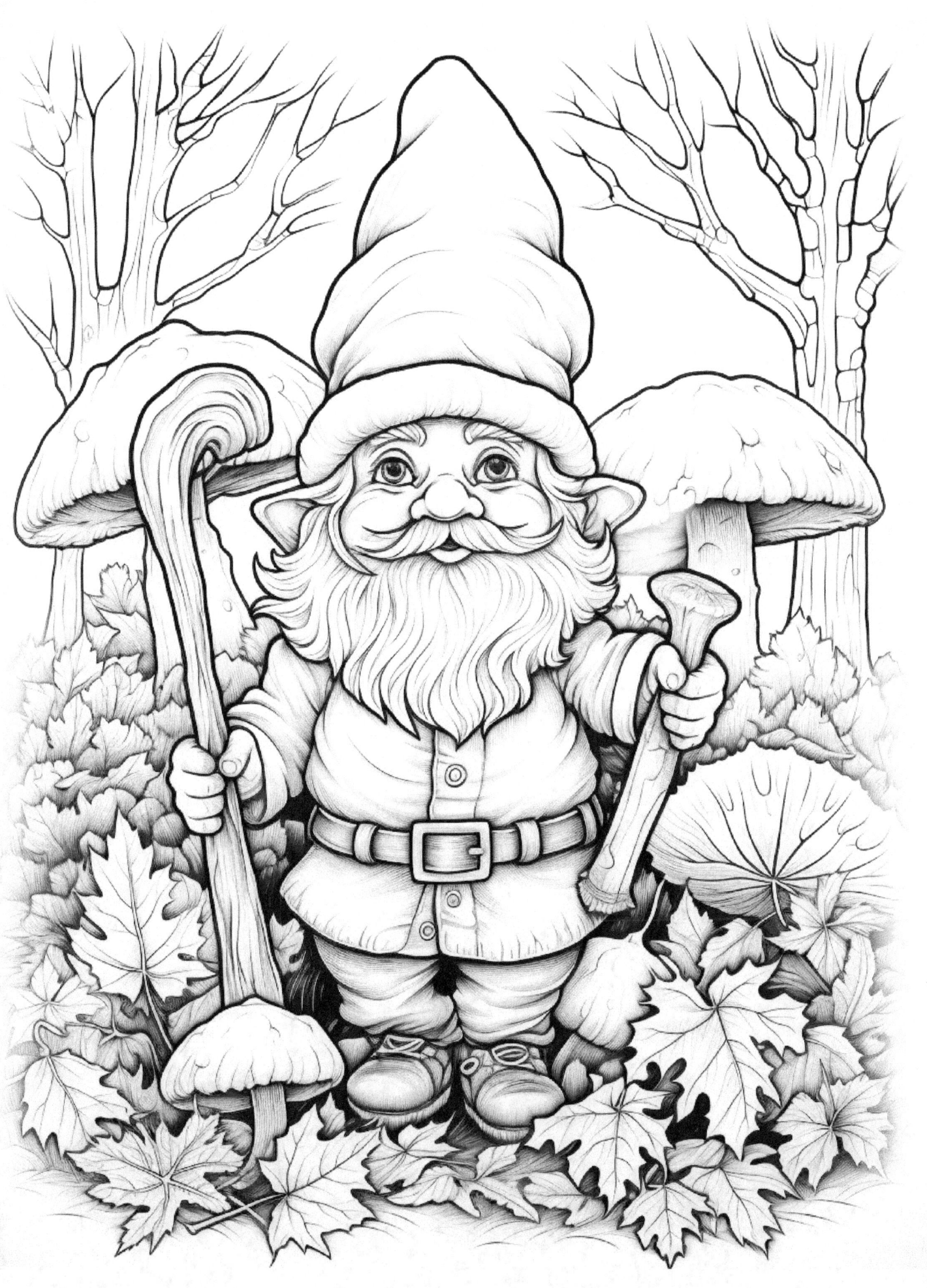

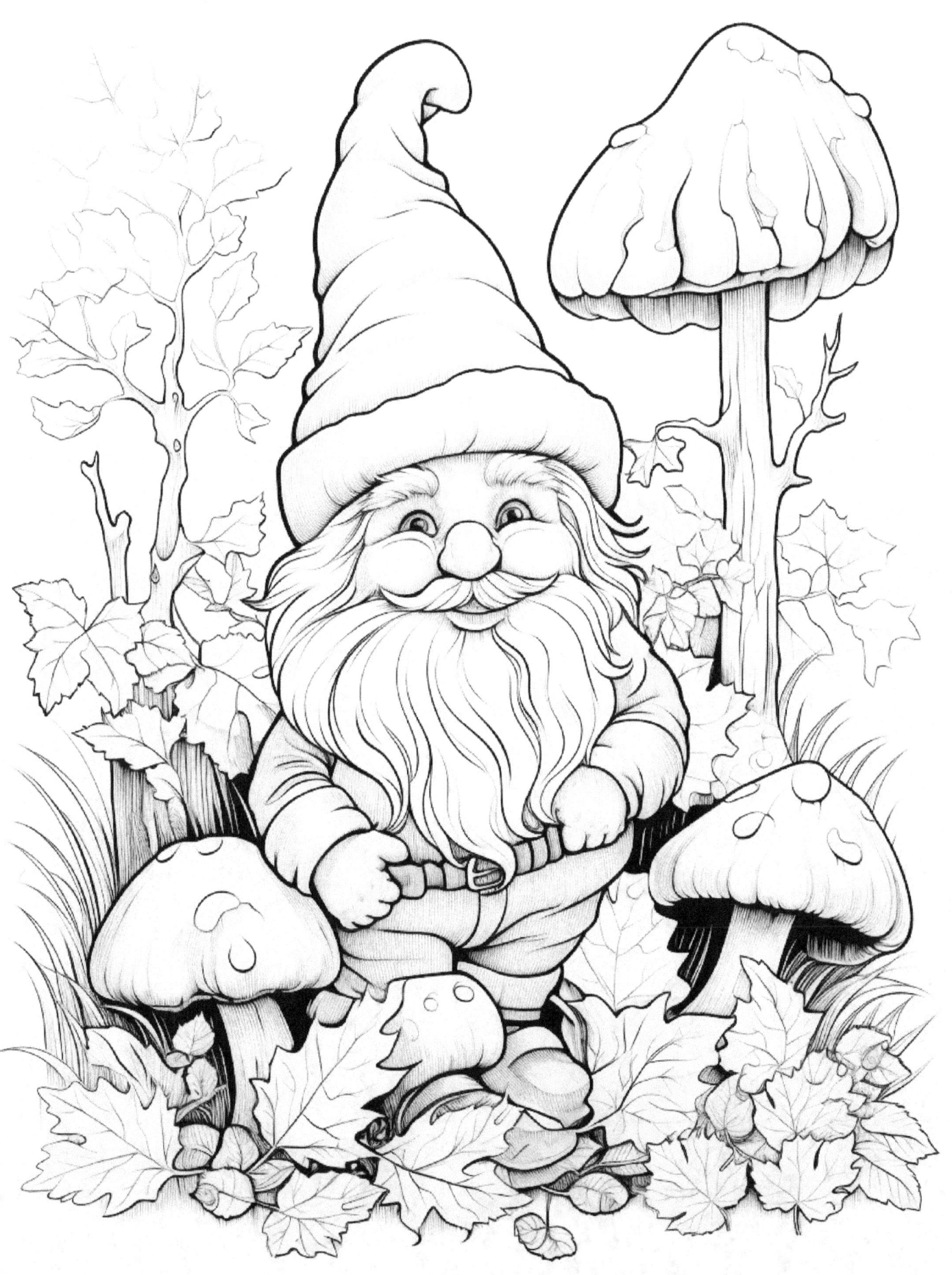

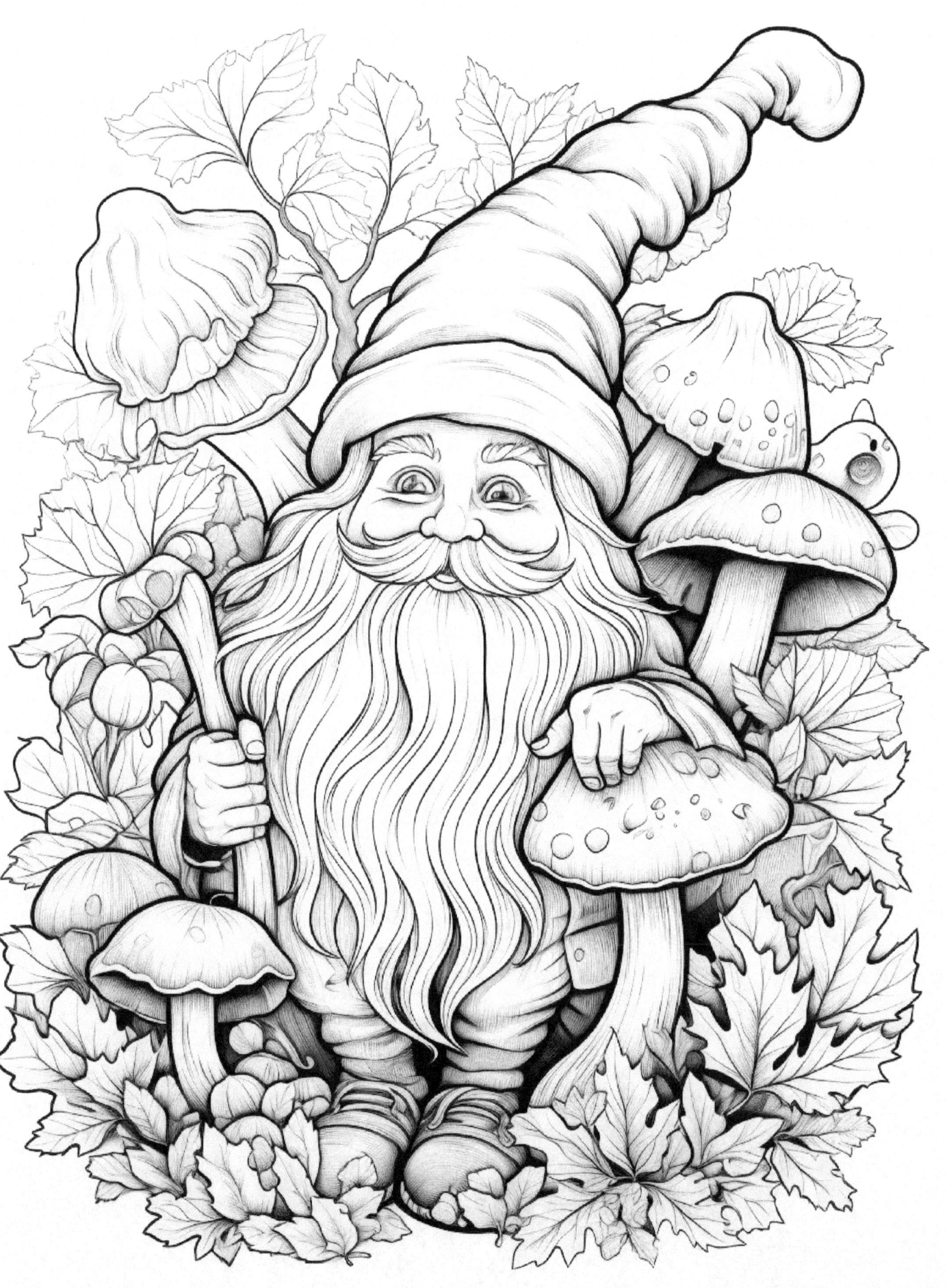

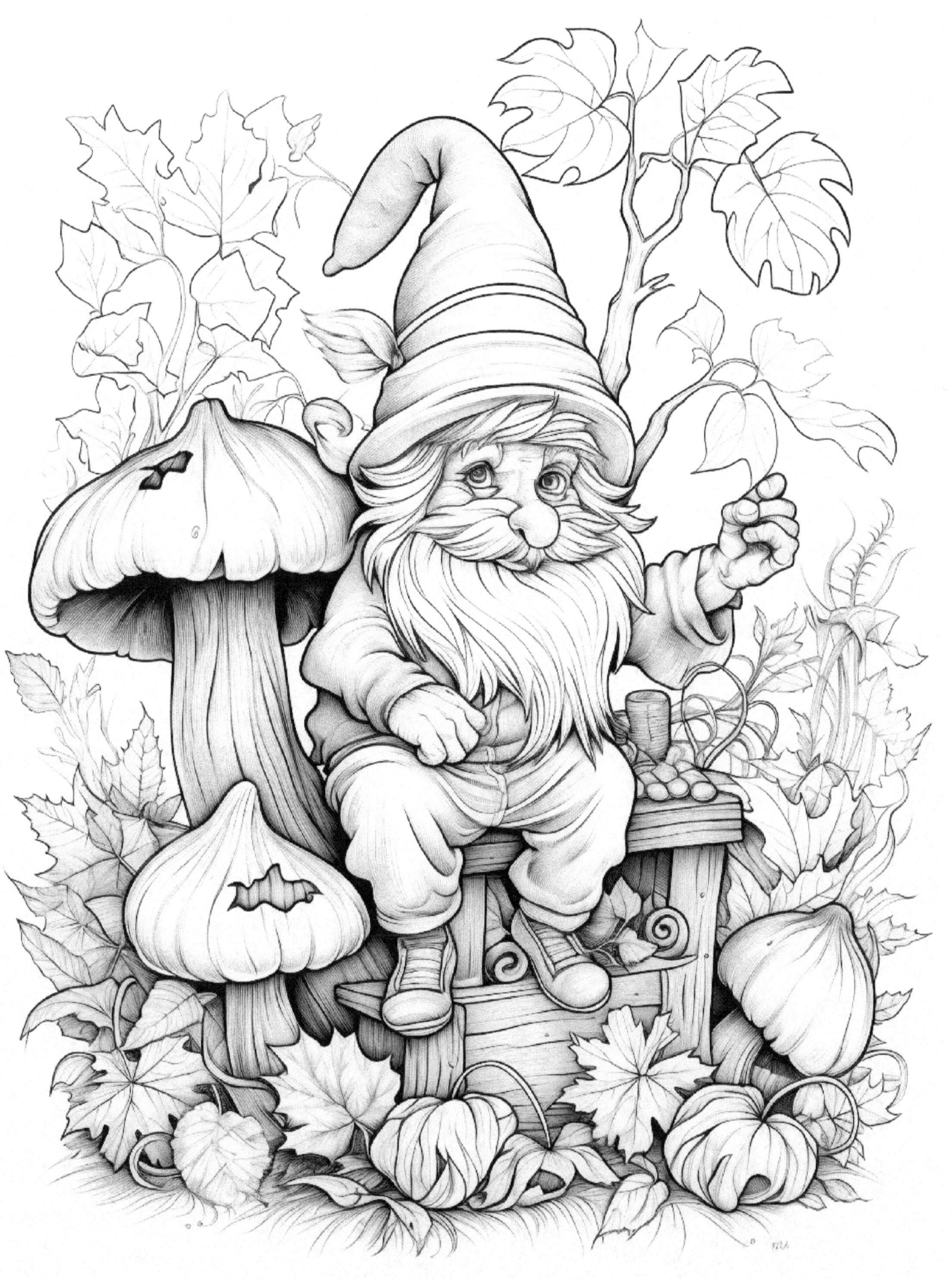

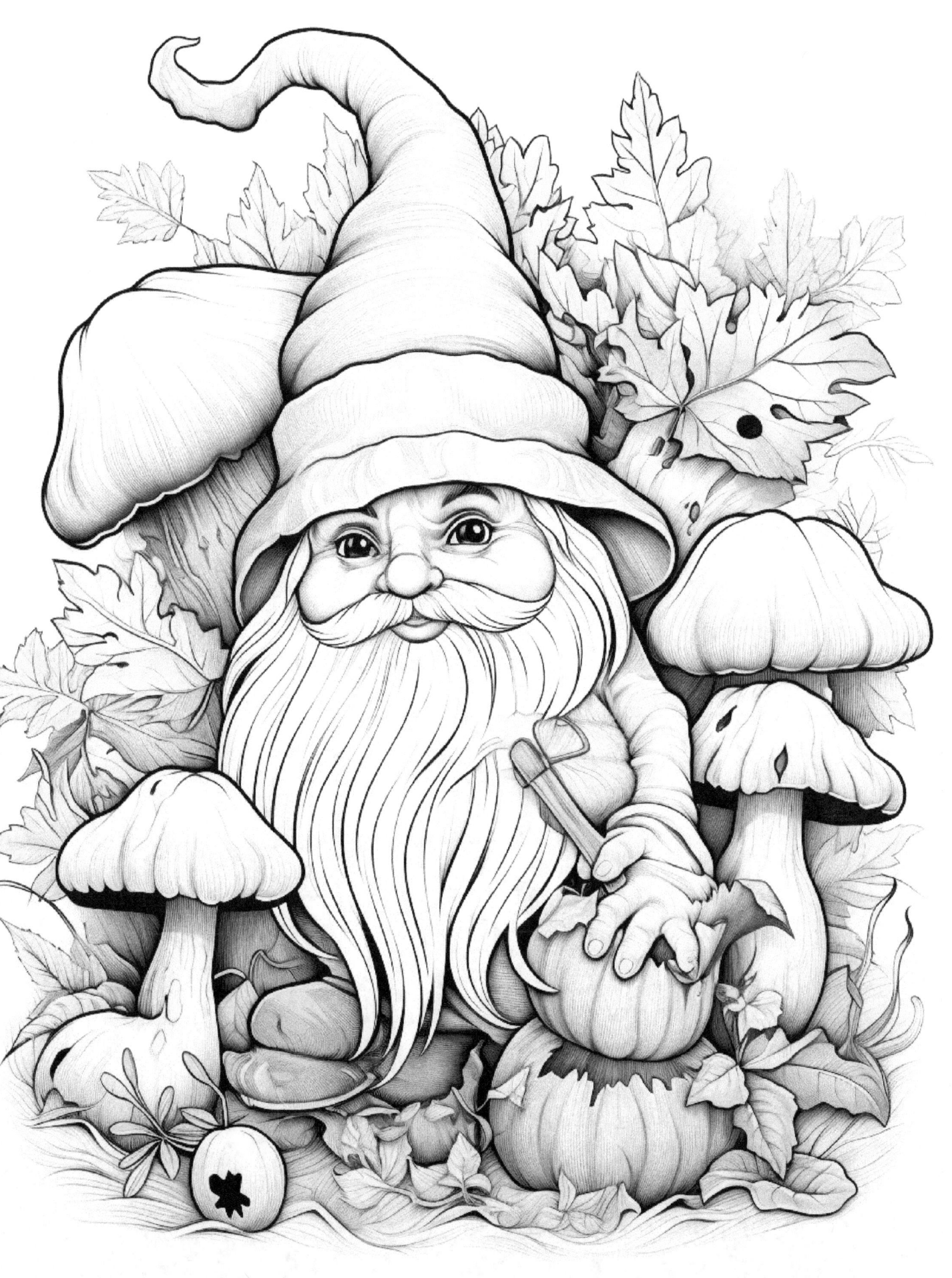

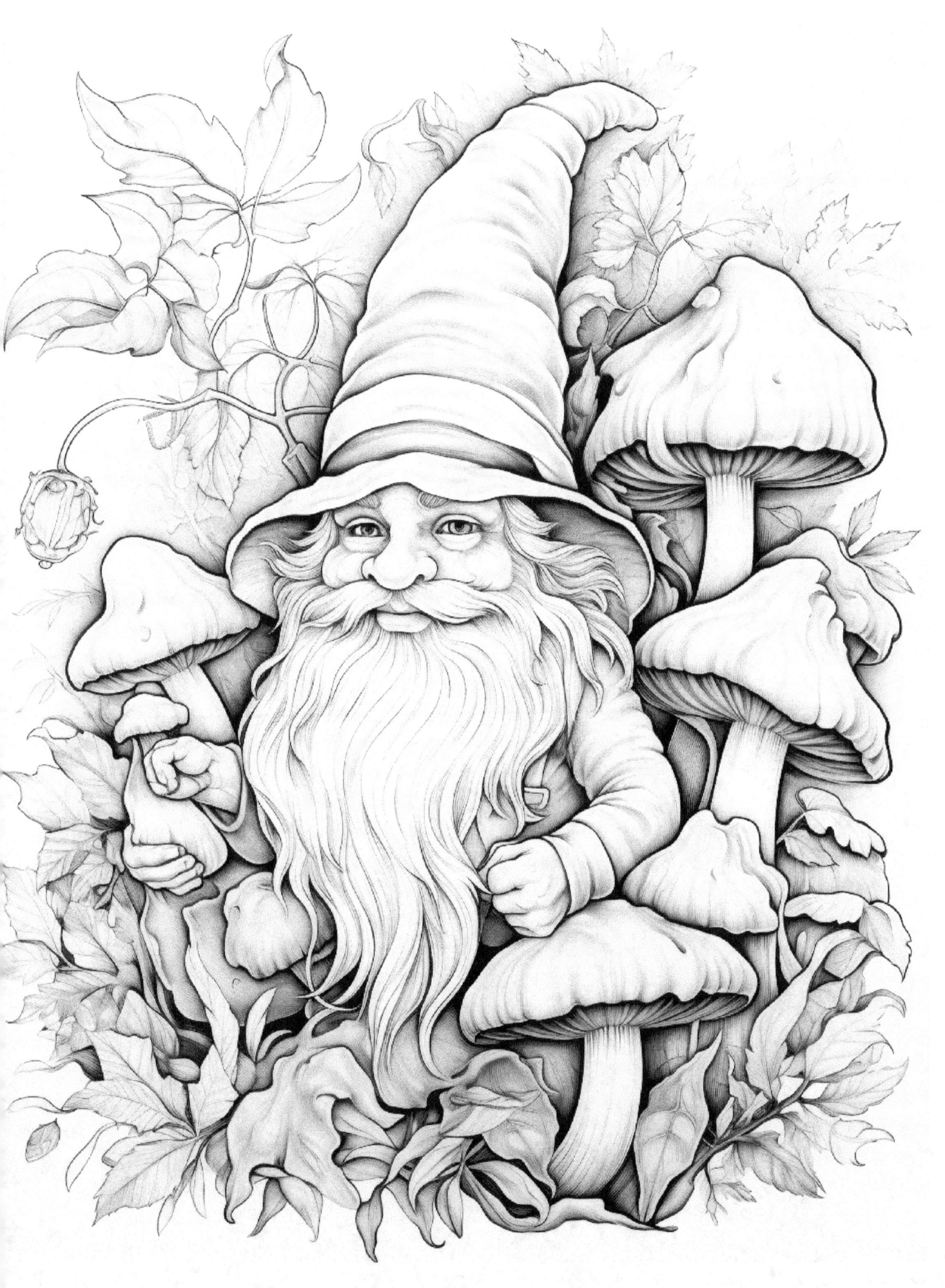

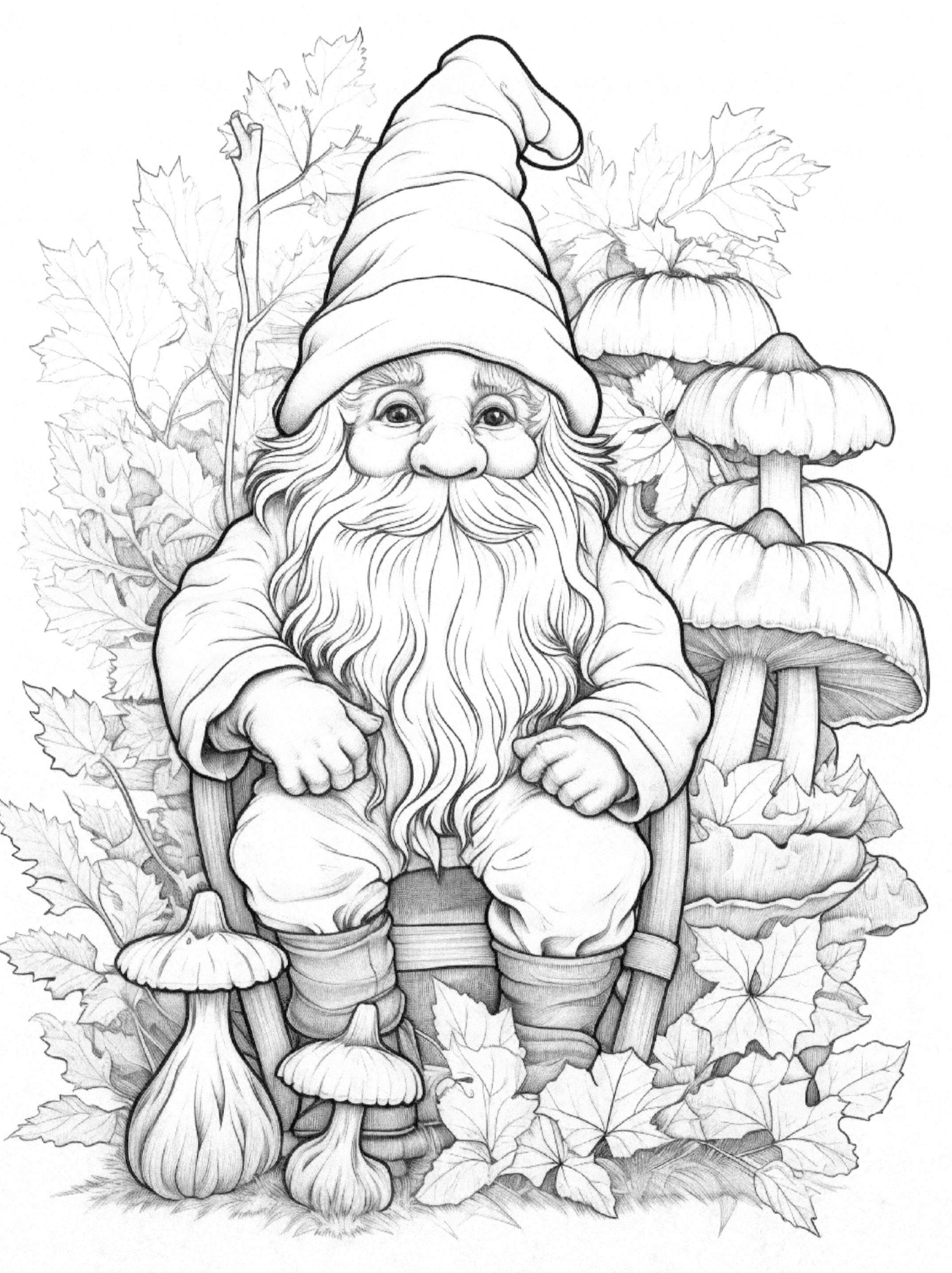

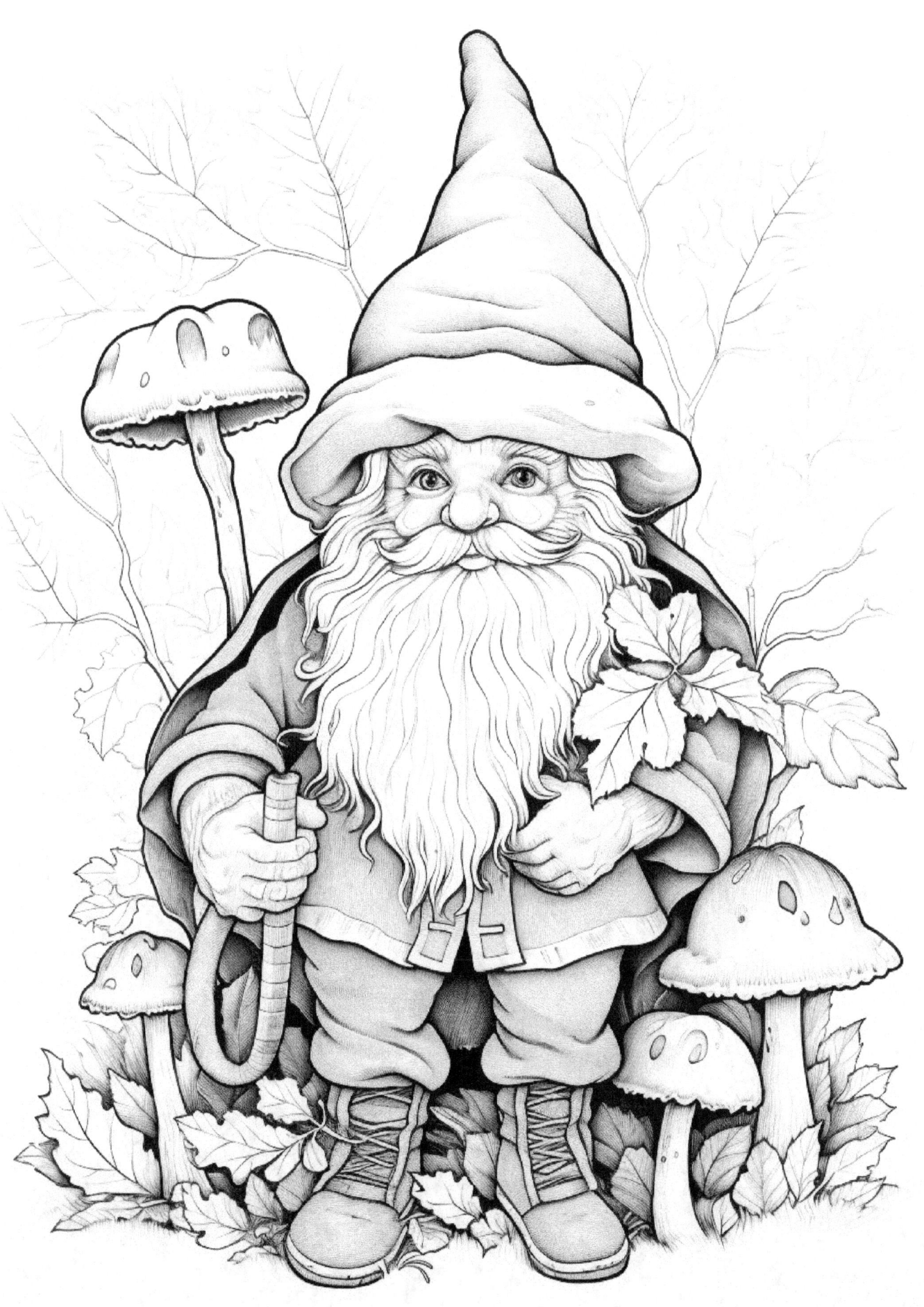

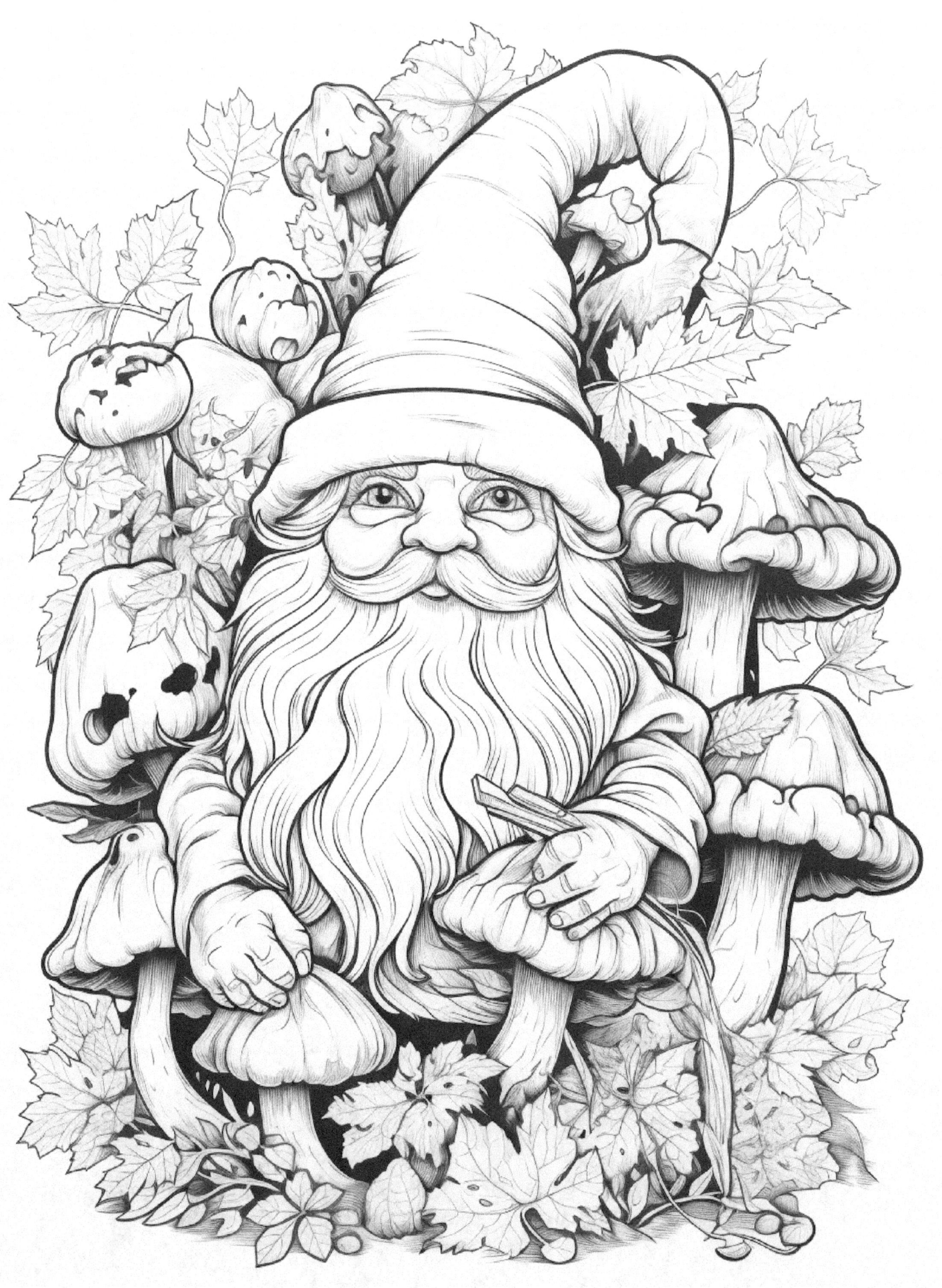

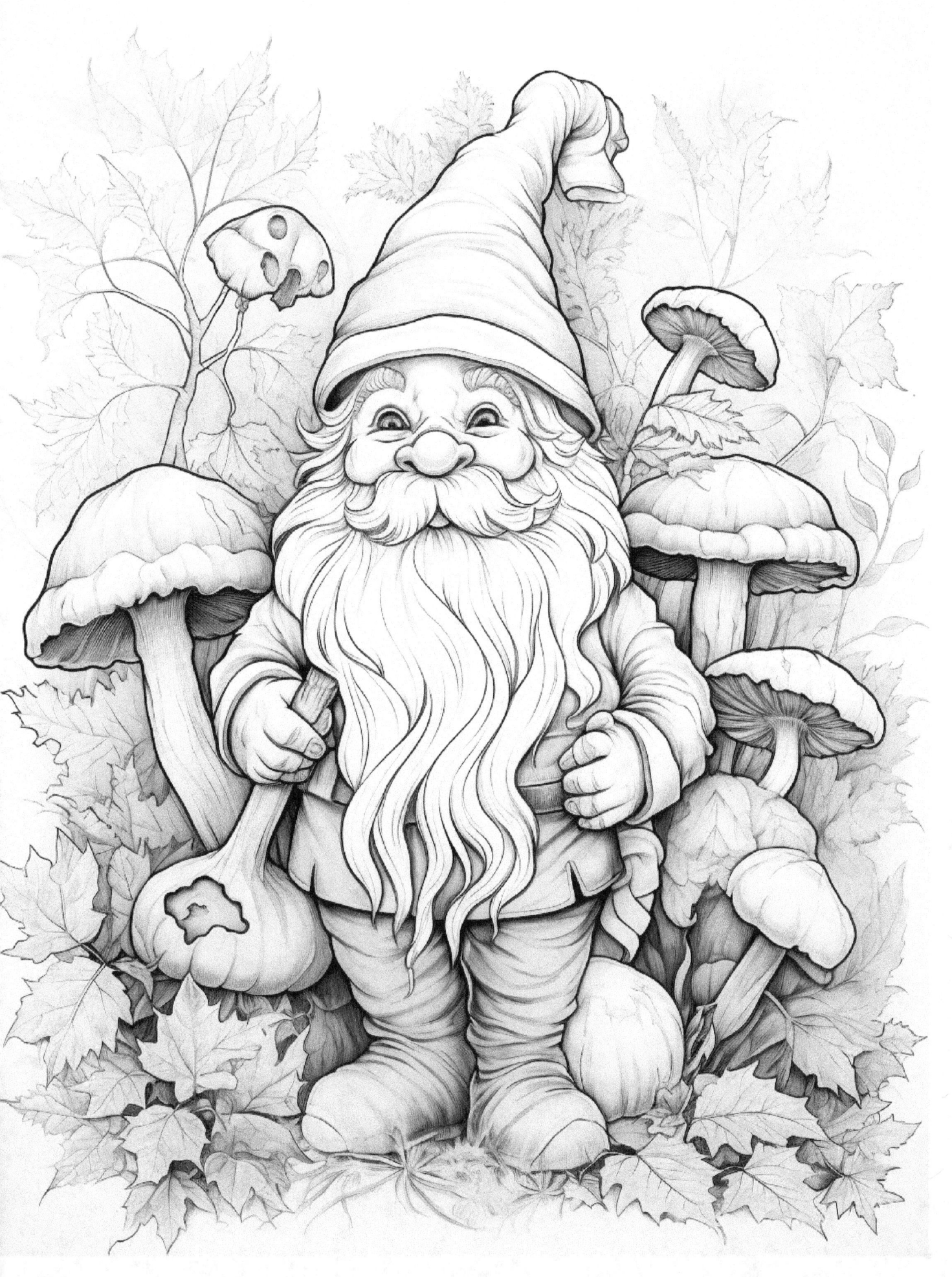

Autumn Gnome

We appreciate you selecting our book, buying our coloring book, and helping our tiny business.

We wish you joy when coloring! We thank all of the contributors to this book for their generosity.

On our Amazon website, kindly post a review and some of your lovely colored photos.

Copyright © 2023-2024 by Al&Vy
All rights reserved

www.ingramcontent.com/pod-product-compliance
Lightning Source LLC
Chambersburg PA
CBHW082236220526
45479CB00005B/1250